POSTCARD HISTORY SERIES

Philadelphia Landmarks and Pastimes

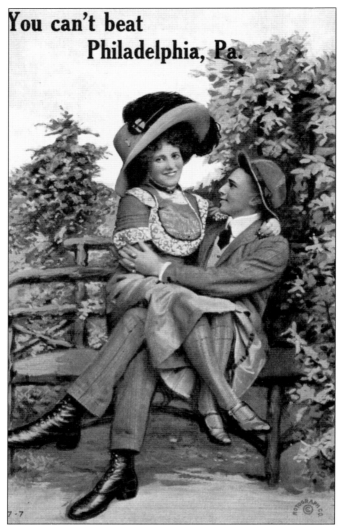

You can't beat Philadelphia, Pa.

In 1910, comic postcards were all the rage. They were typically generic, meaning that the printer added the name of the city after the basic card was printed. However, the caption on this postcard has a special meaning to this book: "You can't beat Philadelphia, Pa."

On the front cover: In the first quarter of the 20th century, Strawberry Mansion, located in east Fairmount Park, became a sprawling haven for a day of rest and relaxation. The Palace Electric Carousel was ensconced within the pleasure dome of the Strawberry Mansion carousel house. A genuine piece of eye candy, it was trimmed with glorious carvings and hand-painted motifs. This postcard is copyright 1907. (Author's collection.)

On the back cover: The All Around Philadelphia Auto Company was one of the first of several sightseeing services that specialized in providing guided tours of Philadelphia. For the price of $1, passengers were treated to a whirlwind ride through the historic, business, and residential areas of the city, as well as the East River Drive. Of course, in 1907, it was entirely feasible to negotiate that route in a shorter period of time, since there were no traffic lights to slow the vehicle down! (Author's collection.)

POSTCARD HISTORY SERIES

Philadelphia Landmarks and Pastimes

Gus Spector

ARCADIA
PUBLISHING

Published by Arcadia Publishing
Charleston SC, Chicago IL, Portsmouth NH, San Francisco CA

Printed in the United States of America

Library of Congress Catalog Card Number: 2008933625

For all general information contact Arcadia Publishing at:
Telephone 843-853-2070
Fax 843-853-0044
E-mail sales@arcadiapublishing.com
For customer service and orders:
Toll-Free 1-888-313-2665

Visit us on the Internet at www.arcadiapublishing.com

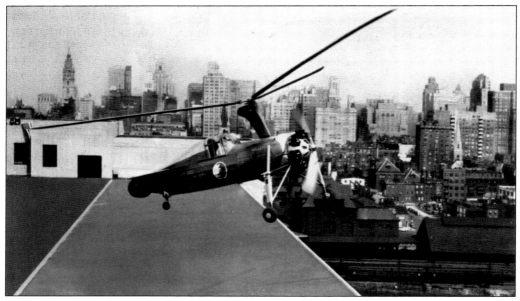

On July 6, 1939, federal mail transportation was initiated utilizing the helicopter-like autogiro.
Rising from the roof of the main Philadelphia post office, the autogiro landed at the Central
Airport in Camden, New Jersey. Control of the direction of flight on this Kellett KD-1 was
accomplished by tilting of the rotor head. The autogiro carried up to 300 pounds of mail
and made five round-trips per day. A glimpse of Philadelphia's skyline in 1939 can be seen in
the background.

CONTENTS

Acknowledgments 6

Introduction 7

1. This Is Show Biz 9

2. Fun for the Kiddies 21

3. When the Rich Had Money 33

4. Where Patriots Have Tread 39

5. Amusement Parks, Midways, and Gladways 51

6. The Right to Assemble 67

7. Crowd Pleasers 77

8. Everyone Loves a Parade 93

9. A City of Museums and Culture 107

10. Signs of the Times 119

ACKNOWLEDGMENTS

This is my fourth book printed by Arcadia Publishing, and I have been privileged to have worked with Erin Vosgien, editor extraordinaire, who has guided me through all the necessary intricacies of each of my volumes. To her I offer my deepest thanks.

This is my third Arcadia book for which Eileen Wolfberg has generously lent her time, encouragement, and skills. She has demonstrated her love of Philadelphia with unbridled vim and vigor.

Again, my hat is off to Clarence Wolf, for his never-ending knowledge of Philadelphia history and trivia and for his accurate suggestions for this book.

I am indebted to Dr. Dennis Lebowsky, a most enthusiastic collector of all sorts of postcards and memorabilia (and my congenial competitor on eBay) for allowing me to peruse his excellent accumulation of Philadelphia cards and publish some of them in this book.

I am also indebted to my California sister, Judith Spector Moorman, for introducing my previous books to Philadelphia expatriates now living on the West Coast.

Most of all, I am so fortunate to be the husband and best friend of Karen Spector. She continues to be my full-time staunchest supporter and my part-time public relations ally.

Unless otherwise noted, postcards are from the collection of the author.

INTRODUCTION

All work and no play certainly can make anyone dull. From Colonial days up until the present, through good times and hardships, Philadelphians have always been eager to seek diversion from their labors. It was said that, even in his 80s, Benjamin Franklin was still composing ballad verses that were chanted by members of a Philadelphia trade union parading through the streets of Philadelphia.

The gala first concert of the Musical Fund Society of Philadelphia was initiated on a subscription basis in 1821. The international exhibition of 1876 introduced visitors to new awareness of the arts, sciences, and manufacturing. The Academy of Music, fashioned after Milan's fabulous La Scala opera house, brought great music, opera, and performers to Philadelphia.

The advent of the electric streetcar gave Philadelphians the opportunity to ride far beyond the city limits and experience the thrills of the amusement parks in the nearby countryside (amusement parks were created and maintained by the transportation companies as a means of increasing ridership). Woodside Park near Fairmount Park, Willow Grove Park, and White City in Chestnut Hill have all vanished but remain alive and well on postcards, as legacies of bygone years.

Fairmount Park, the largest park system in the United States, was a weekend delight for the thousands suffused and suffocated by the din and smell of the city. In its infancy, roads within the park served as carriage and equestrian paths, and after the development of the newfangled automobile, as motorcar byways. The Schuylkill River's banks made for leisurely Sunday picnics, as onlookers cheered the scull crews racing swiftly past. After the dawn of the 20th century, Horticultural Hall and Memorial Hall, buildings from the centennial of 1876, remained as glamorous public monuments. The Fairmount Park Commission, as well as private organizations, shared responsibility for the maintenance of the park's historic buildings so that gems such as Lemon Hill, and Strawberry and Mount Pleasant Mansions, could remain open to the public. The Philadelphia Zoological Gardens, adjacent to Fairmount Park, is the oldest such entity in America.

The Colonial history of Philadelphia has been intimately linked to the history of our nation. Independence Hall, the Liberty Bell, Carpenters' Hall, and the Betsy Ross House grace the city as icons of ultimate importance. The pews in Christ Church and St. Peter's Protestant Episcopal Church, where George Washington and Benjamin Franklin bowed their heads in worship, are still highly venerated.

Philadelphia has always been a sports-oriented town. In 1883, the Phillies played their first season of organized baseball. Between 1910 and 1931, the Philadelphia Athletics, under

the magical managerial skills of Connie Mack, won five world championships and nine league pennants.

The Philadelphia Eagles, named after the avian symbol of Franklin Delano Roosevelt's National Recovery Act, made their debut in 1933. The University of Pennsylvania's Franklin Field was the Eagles' home stadium between 1958 and 1970, after which time the team moved to the new sports arena in South Philadelphia. The Eagles won their division championship 11 times between 1947 and 2006.

The 1926 sesquicentennial celebration's attractions included a new $2 million concrete stadium that would function for many years thereafter, hosting varied sports events, the annual Police and Fireman's Thrill Show, religious conventions, and many musical extravaganzas. In the 1950s, this author attended stock car races there, the lack of adequate guardrails inviting the distinct possibility of injury to the drivers and the fans in the grandstands. The stadium became antiquated and unsafe and was eventually demolished. The surrounding land blossomed into one of the city's greatest triumphs, the sports complex in South Philadelphia.

The reclamation of the swampy acreage in the area adjacent to the Philadelphia Navy Yard and the Schuylkill River created the sesquicentennial grounds and made for its eventual use as a public park. League Island Park, then known affectionately to the locals as "the Lakes," boasted a huge concrete swimming pool, refreshment stands, a lake to rent rowboats to troll for fish, and ball fields. Most of the lakes are gone, having been replaced by Interstate 95 and parking lots for the sports complex. A large portion of the area, however, is now a public golf course, known as Franklin Delano Roosevelt Park.

The Swedes, immigrating to America after 1630, were important early settlers of Pennsylvania, specifically of Philadelphia. Old Swedes' Church, built around 1700, still stands in the Southwark district of Philadelphia. Bordering Franklin Delano Roosevelt Park in South Philadelphia is the American Swedish Museum, an almost-well-kept secret and one of the shining repositories of historic Swedish artifacts.

After the beginning of the 20th century, the real-photo postcards produced by itinerant photographers were, in essence, real-time hard-copy records of events, neighborhood street scenes, disasters, and the like. With his camera, William H. Rau (1855–1920), who immortalized the Johnstown flood and the great Baltimore fire of 1904, also heroically captured bird's-eye views of the Schuylkill River from the dizzying height of a hot-air balloon. He bequeathed to us hundreds of incredibly detailed photographs of the Elks convention of 1907, the 225th anniversary of the founding of Philadelphia in 1908, and the historical pageant of 1912 in Fairmount Park, all of which were placed in historical archives and were also sold as real-photo postcards.

I have been collecting postcards of Philadelphia for over 35 years. Whether attending shows where postcards are sold, logging onto eBay, or gazing through the collections of others, I am constantly in awe of the number of Philadelphia cards that are unfamiliar to me. Early postcard publishers notoriously "borrowed" the images of others, airbrushing them just enough so that the cards could be passed off as their own innovations. There seem to be, for example, an infinite number of different views of Independence Hall, but it is still mind-boggling for me to find previously undiscovered or altered variations on the same theme. My collection has brought me the collector's "thrill of the hunt," searching for more and elusive views, and has also allowed me to have a wonderful supply of research material for this series of books.

Through the medium of postcards, I have attempted to bring to life Philadelphia's rich cultural and historic past, as well as to present a celebration of the ways in which its people found time to have a good time.

One

THIS IS SHOW BIZ

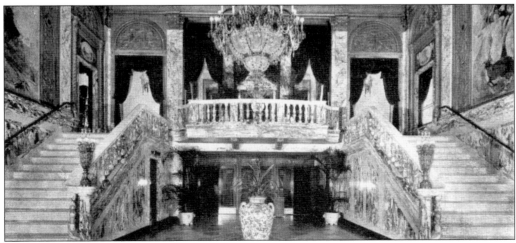

The Earle Theatre, built in 1924, the most costly theater ever erected in Philadelphia, was located at Eleventh Street and Market Street. It boasted multiple lobbies, one of which is seen here in all its glory. Originally a vaudeville theater, it was later altered for movie presentations. The mammoth stage was 62 feet wide and 35 feet deep. The Earle was demolished in 1953.

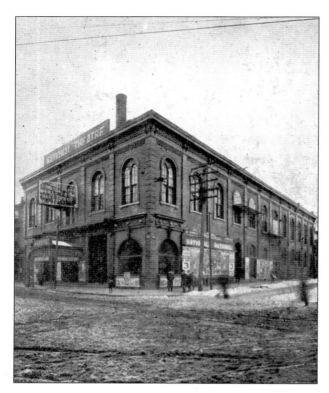

The National Theatre, located at Tenth Street and Callowhill Street, was alive and well in 1853 when a stage version of *Uncle Tom's Cabin* premiered there. The anonymous writer of a contemporary editorial stated that the show had been running for more than three weeks before he was able to obtain a ticket. This *c.* 1905 postcard shows its forlorn, decaying facade.

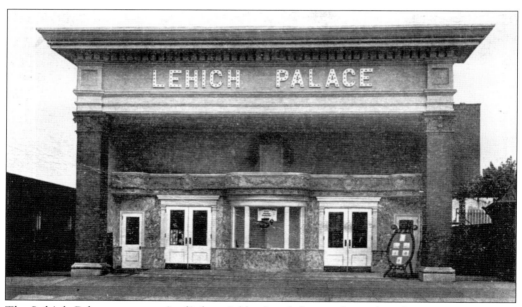

The Lehigh Palace was a quaint little neighborhood theater, located at Germantown Avenue and Lehigh Avenue. According to the sign on the ticket window, admission was the princely sum of 5¢.

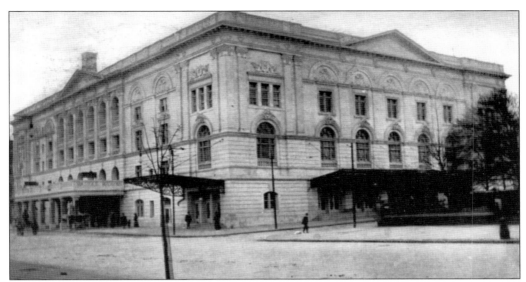

Oscar Hammerstein's Opera House at Broad Street and Poplar Street opened in November 1908 with the opera *Carmen*. The building's 240-foot facade was the longest of any Philadelphia theater. The side facing Broad Street boasted 13 individual entrances, and the seating capacity was 3,482. In the past several decades it has been home to varied ministers and faith healers but currently remains in a sad, deteriorated condition.

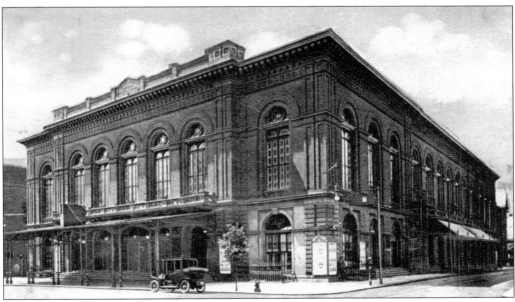

The Academy of Music at Broad Street and Locust Street, designed by Napoleon Le Brun and modeled after Milan's La Scala, opened in 1857. Because of its weight, the huge main crystal chandelier had to be suspended by multiple cables. The ballroom, adorned with crystal chandeliers and mirrored doors, was reminiscent of the Great Hall of Versailles. Beginning in 1900 and for 101 consecutive seasons, it was home to the Philadelphia Orchestra. The card was postmarked in 1909.

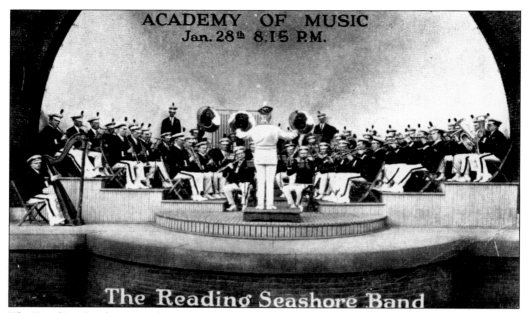

The Reading Seashore Band appeared in concert at the Academy of Music. This *c.* 1920 postcard was created when the band's featured artists, Titta Ruffo and Yvonne D'Arle, were both very popular. (Courtesy of Dennis Lebofsky.)

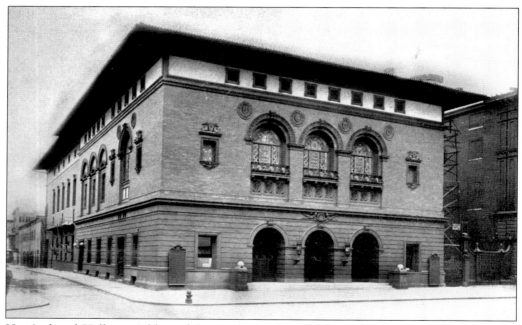

Horticultural Hall, a neighbor of the Academy of Music, located at Broad Street and Spruce Street, opened in 1876. It was most noted for its Florentine facade graced by exquisitely executed stained-glass windows and for its beautiful, ornate staircase. The hall was rebuilt in 1895 after its destruction by fire, only to be razed in 1917. The Schubert Theatre, now the Merriam Theatre, was erected on the site in 1918.

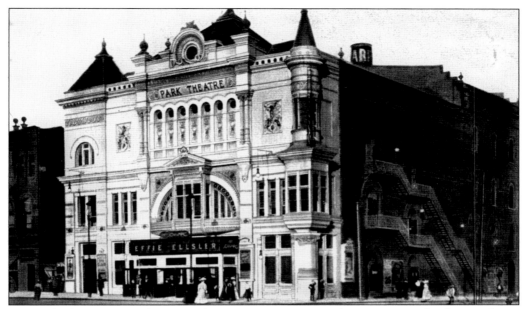

The Park Theatre at Broad Street and Fairmount Avenue was the inspiration of architect John B. McElfatrick, who also designed Hammerstein's Opera House. The Park Theatre opened in 1889 and was demolished in 1968. The theater's marquee advertised Effie Ellsler (1855–1942), who had appeared in a number of melodramatic plays and in movies with stars such as Greta Garbo and Adolph Menjou.

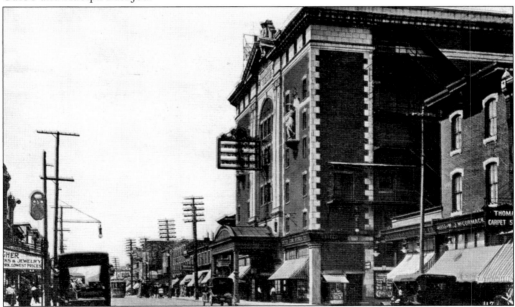

The William Penn Theatre, at Forty-first Street and Lancaster Avenue in West Philadelphia, opened in 1909, touted as a first-class vaudeville house. The property, originally owned by Gustavus Wegefarth, was only two-thirds completed when he committed suicide in 1908 as a "result of business reversals." The building immediately sold at public auction to real estate broker Felix Isman for only $80,000 (around $1.8 million in 2007 dollars).

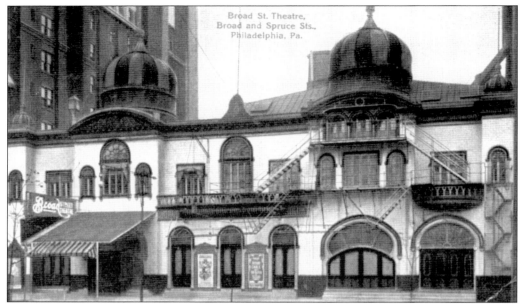

The Broad Street Theatre, located across the street from the Academy of Music, is seen in this 1908 view. Originally named Kiralfy's Alhambra Palace, it opened during the centennial year of 1876, presenting lavish musical extravaganzas that included live dogs, an elephant, and other animals. The elaborate Moorish facade was designed by architect Frank H. Loenholdt. The theater closed in 1937.

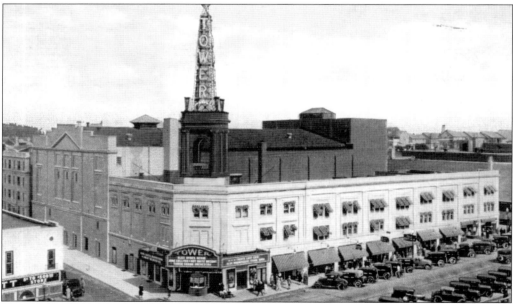

The Tower Theatre, which had opened in 1928, was in its heyday when this postcard was mailed in 1931. Situated at Sixty-ninth Street and Market Street within a busy business district, it featured both vaudeville acts and movies. By 1970 the theater showed only third-run films, and admissions were reduced to $1. In 1972, it was reintroduced as a rock concert hall and subsequently featured many outstanding artists. (Courtesy of Dennis Lebofsky.)

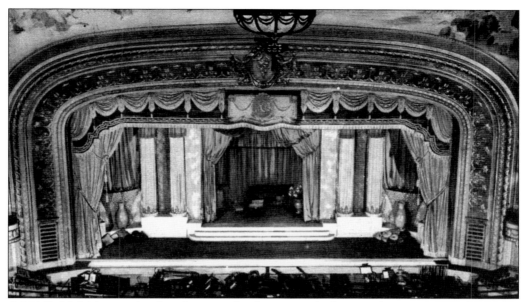

Of Philadelphia's two Stanley theaters, the first, named after Stanley Mastbaum, located at Sixteenth Street and Market Street, opened in 1914. In 1921, its name was changed to the Stanton, since a more ornate, opulent Stanley Theatre was erected at Nineteenth Street and Market Street. The Stanley orchestra was deemed to be a world–class ensemble. The massive stage and orchestra pit, pictured around 1915, appears ready for its next concert.

The world premiere of Jesse L. Lasky's *The Virginian* was featured at the Stanley Theatre on September 7, 1914. *The Virginian* was a pioneering Western feature directed by Cecil B. DeMille. Lasky was presenter of over 450 movies and producer of 132 films, including *The Great Caruso* (1951) and *The Great Gatsby* (1926). He was memorialized in the Hollywood Walk of Fame. He died in 1958 at age 78.

The Stanley

PROGRAM

Week Beginning, Monday, September 7, 1914

The First Showing in the Entire World of Productions of the Paramount Pictures Corporation.

JESSE L. LASKY

OF THE PARAMOUNT COMPANY PRESENTS

Mr. Dustin Farnum

IN HIS ORIGINAL CHARACTER

"THE VIRGINIAN"

Pictured from the Wyoming epic by OWEN WISTER

The Program consists also of many other interesting subjects, which are not specially advertised, as the management selects these at a late date from the world's output.

COMEDIES

INDUSTRIALS EDUCATIONALS

TRAVELOGUES, IN NATURAL COLORS

STANLEY NEWS SERVICE

The Stanley Symphony Orchestra

HARRY W. MEYER } Directors
AL. WAYNE

Also

ORGANISTS : ROLLO MAITLAND, RICHARD BACHE

PIANIST : WILLIAM PAUL

We respectfully call the attention of our patrons to the Musical Program.

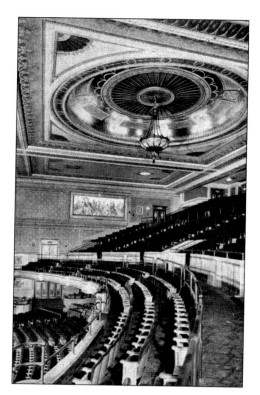

The magnificent upper balcony and ceiling of the Stanley Theatre are seen in this postcard from 1915. On the mezzanine floor were situated reading and writing rooms, a men's smoking room, and a telephone. Other amenities included a service that would deliver messages gratis within a five-block radius of the theater, and an on-call house physician.

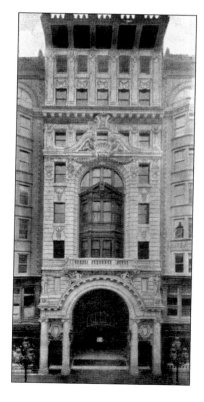

Keith's New Million Dollar Theatre, the most prominent vaudeville house in Philadelphia, located at 1116 Chestnut Street, is seen in this 1905 postcard. As narrow as the building appeared, the theater actually extended a full block from front to back. By 1949, with the public's fascination of vaudeville in decline, it was converted into a motion picture theater. It finally closed in 1971.

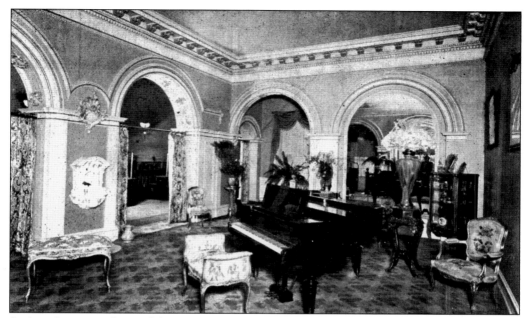

An interior view of one of the reception rooms in Keith's Theatre is seen in 1912. The inviting French Renaissance décor gave the illusion of sitting in one's own living room rather than in a theater lobby or music room.

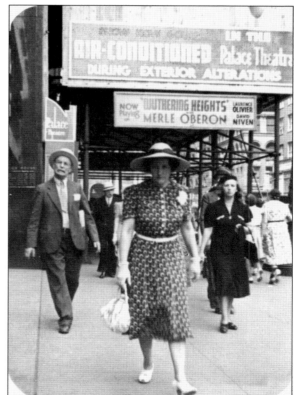

The Palace Theatre, located at 1214 Market Street, had been built in 1908 for Siegmund Lubin, one of the film industry's greatest pioneers. In 1921, it was renovated into a showplace for both vaudeville and movie presentations. As displayed on the theater's marquee, Merle Oberon received top billing in the 1939 movie *Wuthering Heights*.

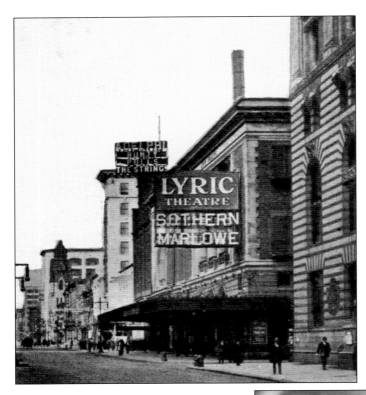

Architect James H. Windrim designed both the Adelphi and Lyric Theatres, which were erected side by side at Broad Street and Cherry Street. The Lyric opened in 1905, the Adelphi two years later. Both were demolished in 1937. The Adelphi's feature presentation in this view is *Bunty Pulls the Strings*. This dated film, released in 1921, was recently critiqued by a sarcastic blogger who wrote, "She can pull the string that flushes this movie."

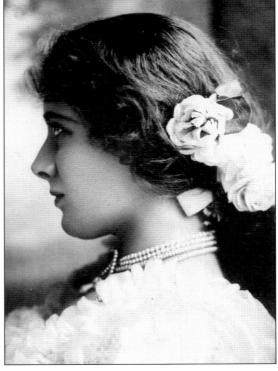

The names Sothern and Marlowe, seen atop the Lyric Theatre's sign in the above postcard, referred to Edward Hugh Sothern (obviously receiving top billing), who divorced his first wife to marry actress Julia Marlowe. The pair was deemed the finest Shakespearian actors of the day. This publicity postcard revealed a young, beautiful Julia Marlowe, who died in 1950 at age 86, outliving her husband by 17 years.

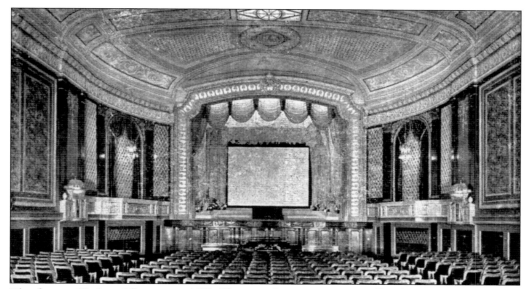

The former Karlton Theatre, at 1412 Chestnut Street, an ornate affair built in 1921, boasted 42 rows of seats. The interior of the theater is seen in this 1924 view, its 12 exit doors situated beneath the stage. In 1954, it was converted into duplex auditoriums and became the Midtown, later the Budco Twin Theatre. The site was renovated in 1999, reincarnated as the Prince Music Theater. (Courtesy of Dennis Lebofsky.)

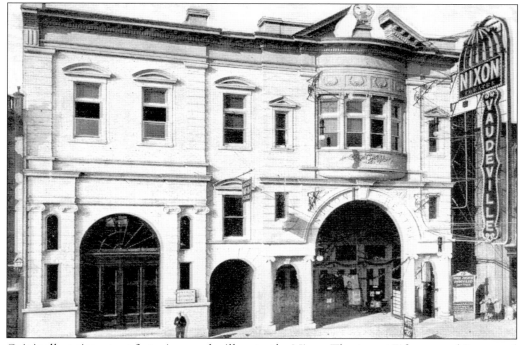

Originally a circus tent featuring vaudeville acts, the Nixon Theatre, at Fifty-second Street and Market Street, opened for business in 1910. The theater, seen here in 1915, offered vaudeville performances at 10¢ per admission (around $2.20 in 2007 dollars). The theater was demolished in 1984. (Courtesy of Dennis Lebofsky.)

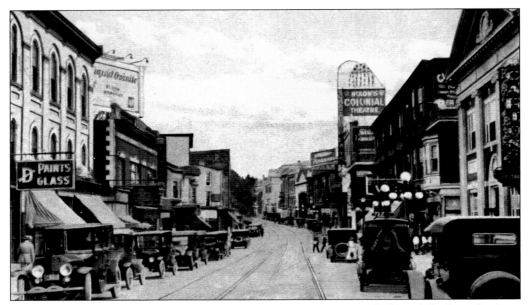

The huge rooftop sign advertising Nixon's Colonial Theatre overshadowed the busy business district in the 5500 block of Germantown Avenue. The theater was built in 1913 and, like many other aging neighborhood theaters of that era, met its demise in 1960.

In the early 20th century, "hayseed" humor was ever-present on the vaudeville stage. The country hick character "Uncle Josh," well known to theater audiences and in early recordings, had traveled from New Hampshire to gawk at the sights and sounds of the big city. In 1911, the Grand Opera House, located at Broad Street and Montgomery Avenue, was host to the 26th season of *The Old Homestead*.

Two

FUN FOR THE KIDDIES

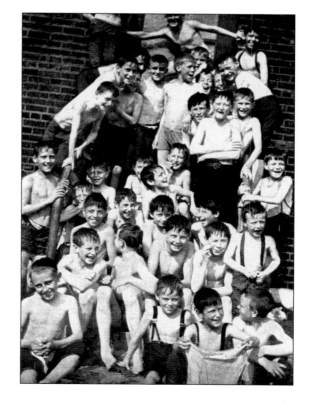

Summer should be a time of real fun for children. In 1910, the Playgrounds Association of Philadelphia produced a series of postcards exemplifying the organization's projects and activities. A bevy of happy faces is evident here, the kids having just hopped out of one of the local pools, otherwise known in Philadelphia slang as "the swimmies."

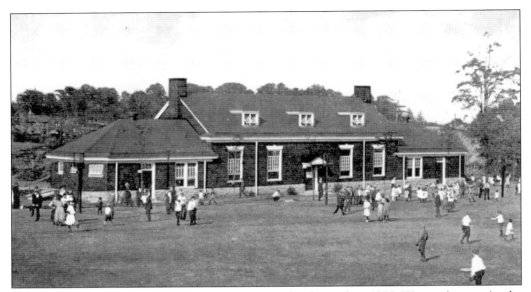

Happy Hollow Recreation Centre and Playground is located at 4800 Wayne Avenue in the Germantown section of Philadelphia. Opened in April 1911, its goal was to provide every youngster in its catchment area with the opportunity for supervised play at the cost of 1¢ per day, in the hopes of reducing crimes committed by youngsters. The recreation center remains at this site today.

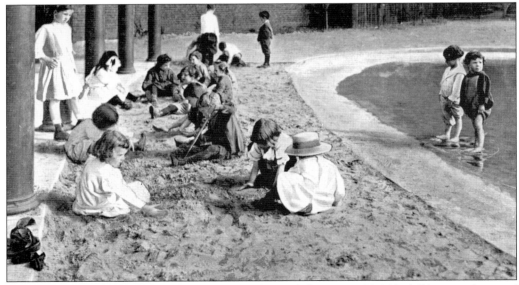

The Playground Organization of Philadelphia boasted that over 600,000 children made use of its playgrounds in 1910. Happy Hollow's amenities included a sandy beach and a wading pool. This view was obviously taken many years before the advent of sunblock.

Unfortunately, not all children were able to experience happy summer days, since many dwelled in the squalor of mean, deteriorating neighborhoods. This *c.* 1910 postcard was produced by the Board of Home Missions of the Methodist Episcopal Church of Philadelphia. Ironically entitled "The City's Glamour," its printed message sought donations of $500 to $10,000.

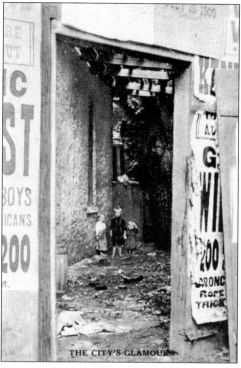

THE CITY'S GLAMOUR

The Ferry Playground, located on Gray's Ferry Road near Twenty-seventh Street, apparently did not acquire the funding necessary for more extensive facilities, since it merely consisted of a single swing set and a small baseball field. The only green grass seen by these kids had sprouted up between the cracks in the concrete.

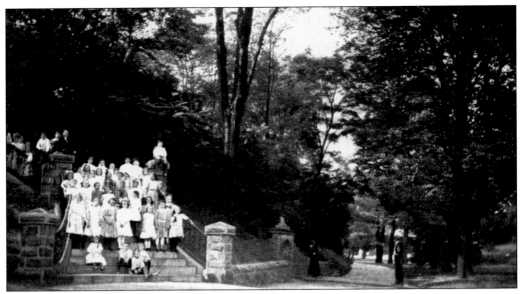

A group of nattily dressed boys and girls are posed on the steps of the approach to Fairmount Park's Lemon Hill. The photograph was taken in 1912 near the Lincoln Monument on the East River Drive. Lemon Hill is but one of the lovely areas within the huge Fairmount Park system.

In 1907, the falls at Fairmount Park's Chamonioux Lake offered a clean, idyllic rest stop for these young hikers. Chamonioux Lake no longer exists.

24

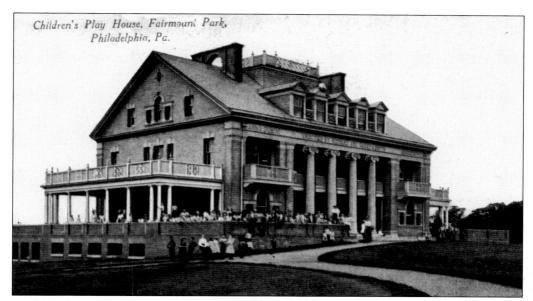

Children's Play House, Fairmount Park,
Philadelphia, Pa.

In 1894, the estate of Richard Smith, a wealthy Philadelphia type founder, provided $50,000 for the construction of a children's playhouse. The building, seen in this postcard from 1915, opened in 1899 in Fairmount Park and has never charged an admission fee. The facility, still located in the east park, continues to serve its original purpose.

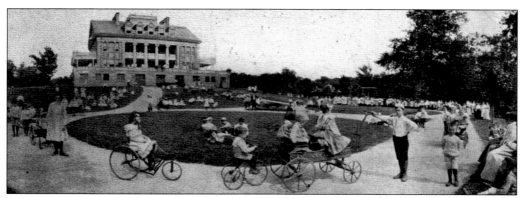

According to Smith's will, male children over the age of 10 were to be excluded from the playground, in the hopes that it would remain a safer place for younger tots. In this 1909 view, a group of small children is seen wheeling bicycles about its expansive circular path. The playhouse can be seen in the background.

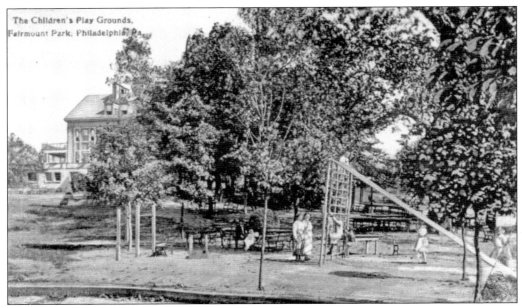

Smith's Playground, located on a gently sloping plot, provided various daytime activities for children. The playhouse can again be seen in the background in this postcard from 1911. (Courtesy of Dennis Lebofsky.)

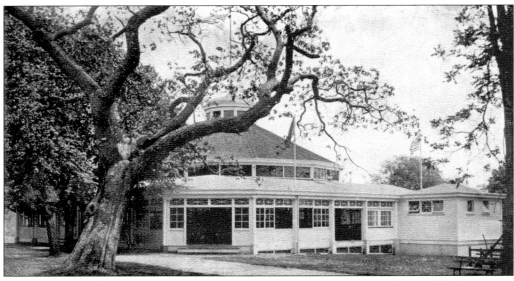

Fairmount Park's Strawberry Mansion carousel house is seen in this view from 1901. The elegant hand-carved, hand-painted mechanical merry-go-round that was housed within it can be seen on the front cover of this book.

The Fairmount Park Aquarium, located in the belly of the abandoned Fairmount Water Works, opened in 1916. The tanks were originally filled with untreated Schuylkill River water, which was soon found to be toxic to the fish and had to be replaced with city water. The deteriorating aquarium was forced to close in 1962, but the waterworks itself recently was restored and is a museum in its own right. This 1930 view shows one of the rooms containing saltwater tanks.

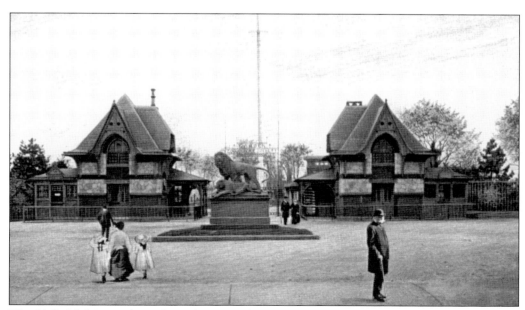

The Philadelphia Zoological Gardens was chartered in 1859 but did not officially open until 1874, after the Civil War. The front entrance of America's first zoo, seen in this 1907 view, was designed by architect Frank Furness. The entrance and its imposing statuary remain basically unchanged today.

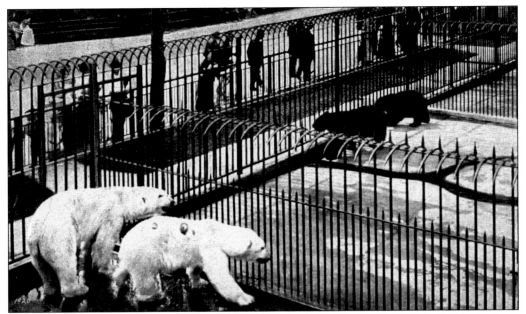

Several of the Philadelphia Zoo's missions have been the preservation and maintenance of rare species and the education of the public concerning the fragility of life and the importance of the interplay between ecosystems. In 1915, there being as yet little consideration given to habitat and living conditions, these beautiful animals were merely incarcerated in "bear pits" and cages.

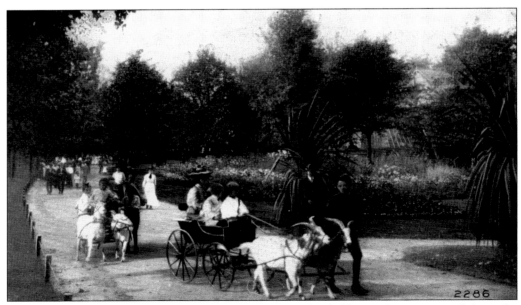

Long before the era of the monorail, it was a great treat for children to be transported about the zoo grounds in goat-drawn carts.

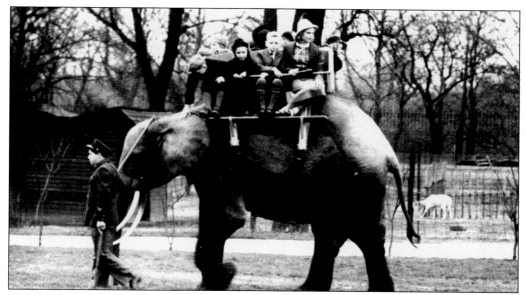

This 1940s postcard, published by the Zoological Society of Philadelphia, pictures Josephine the elephant travailing under the heavy human burden upon her back. At the time, Josephine was the only tame African elephant in America.

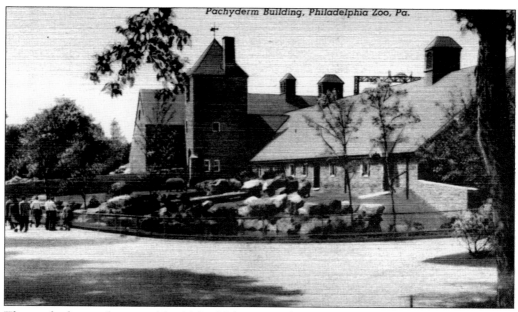

The pachyderms (beasts with thick skin) were otherwise sequestered in their mammoth building that had been erected in 1941. The powerful animals were kept from escaping by means of deep moats, which practically eliminated the use of constraining bars and wires. The Philadelphia zoo is currently in the process of closing this exhibit and transferring the elephants to other zoos.

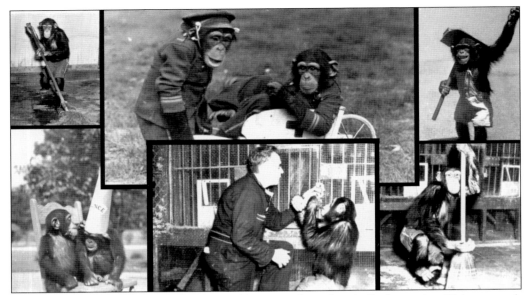

In 1946, the zoo had a more festive, circuslike atmosphere than it displays today. This postcard, showcasing its chimpanzees in anthropomorphic garb and poses, was also published by the Zoological Society of Philadelphia.

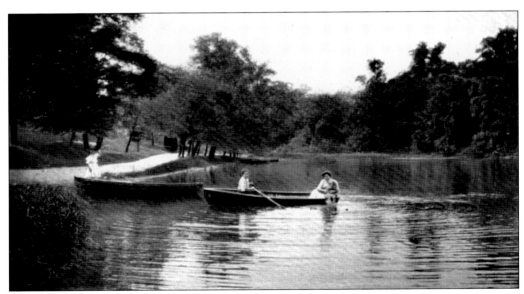

It was great fun for a boy and his mom to drift about in a rowboat on a quiet Sunday afternoon on Chamonioux Lake in Fairmount Park. This card was mailed in 1908.

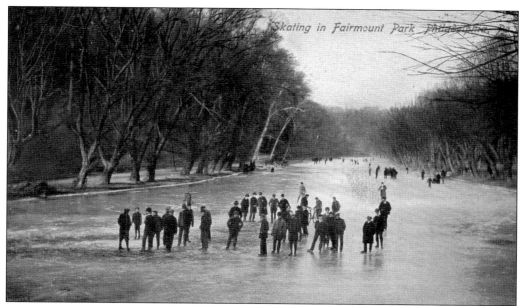

Posted in March 1909, this card was entitled "Skating in Fairmount Park." The crowd, approximately 15 persons across, occupied nearly half the width of this frozen section of Fairmount Park's Wissahickon Creek.

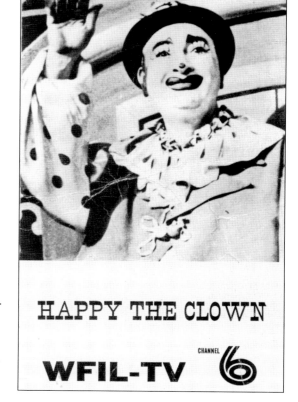

By the 1950s, television had become an established household entity, and children sat wide-eyed, mesmerized by the fuzzy images on the tiny black-and-white screen. A number of children's shows emanated live from local Philadelphia studios. Howard Jones, also known as Happy the Clown, was a Philadelphia Channel 6 icon from 1956 until 1968. He died in 1993. (Courtesy of Dennis Lebofsky.)

Between 1950 and 1953, Pete Boyle starred in a one-hour noontime cartoon show on Channel 3 entitled *Lunch with Uncle Pete*. In 1953, many children in Philadelphia public schools went home for lunch. Uncle Pete became so popular that the show had to be cut back to only one half hour, since students were late returning to school. Uncle Pete died in 1967. He was the father of actor Peter Boyle. (Courtesy of Dennis Lebofsky.)

Three

WHEN THE RICH
HAD MONEY

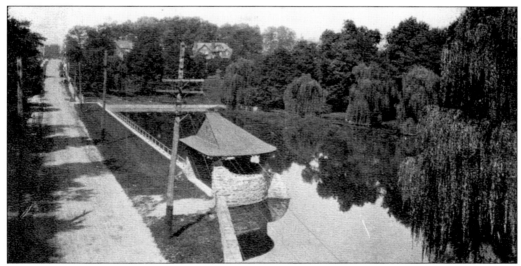

Oak Lane, the area east of the northern terminus of Broad Street, presently a rather short journey from Center City was, in the late 19th century, a haven for the rich. This 1905 postcard views City Line (now Cheltenham Avenue) at Asbury's Lake. T. Henry Asbury, wealthy owner of the Enterprise Manufacturing Company, envisioned the wasteland as a virtual paradise and constructed many lovely cottages there. Today Lakeside Avenue meanders between Cheltenham Avenue and Old York Road and intersects with Asbury Terrace.

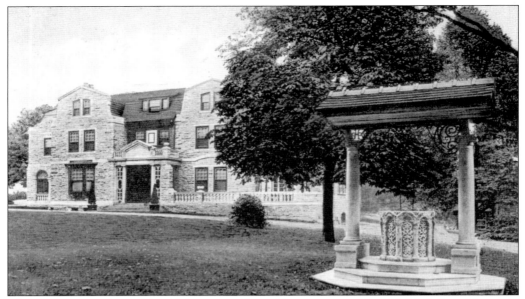

This 1912 postcard, not identifying a specific residence, was entitled "A York Road Lawn in Oak Lane." The dwelling was immense, with the lawn and the somewhat sparse shrubbery having been neatly manicured.

The idyllic artificial lake seen in this 1905 view was located in Oak Lane, on the property of the summer residence of Edward Bromley. Bromley's city home was recorded in the *Philadelphia Blue Book* of 1905 at Broad Street and Berks Street. Although his city address was less than six miles from his summer residence, the two were certainly worlds apart.

The Smith Mansion, otherwise known as "Carlton," located near the Queen Lane reservoir, was built around 1780. It was owned by Cornelius S. Smith, who had purchased the original 84 acres in 1840. Over the ensuing years and into the 1880s, he sold large portions of the estate. Unfortunately, the property was demolished in 1951.

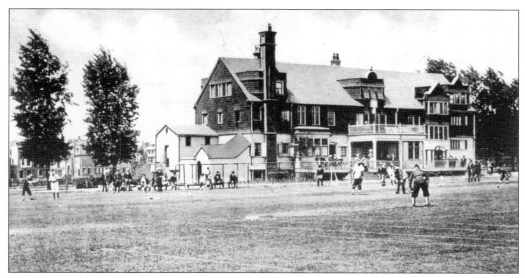

The Belmont Cricket Club was an upscale country club located at Fiftieth Street and Chester Avenue in West Philadelphia. It was founded in 1874 and closed in 1914. In this 1908 view, an exciting game of cricket is underway.

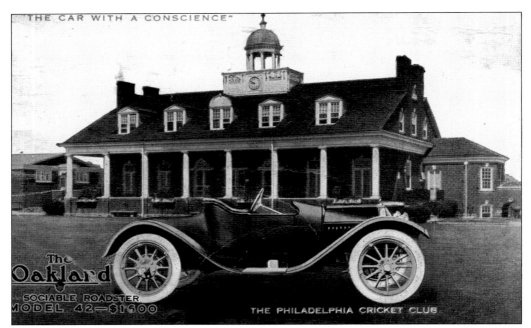

The Philadelphia Cricket Club, the oldest cricket organization in the United States, was founded in 1854 and was located in Chestnut Hill. Although its cricket team was disbanded in 1924, the facility remained open for swimming, tennis, and squash. The magnificent Oakland Sociable Roadster, selling for $1,600 in 1913 (around $33,000 in 2007 dollars), was parked in front of its main entrance.

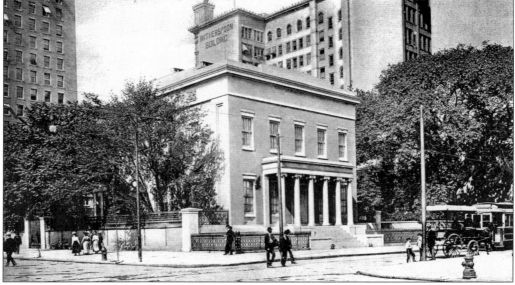

The Dundas–Lippincott mansion, also known as the "Yellow Mansion," was built in 1839 by James Dundas on the northeast corner of Broad and Walnut Streets. Once considered the most expensive property in the city, it was sold for $2,625,000 in 1905 (around $60 million in 2007 dollars), and was razed soon thereafter. The Fidelity Bank building was then erected upon the site. This card was postmarked in 1905.

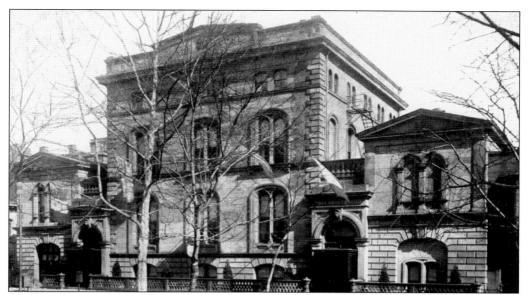

The residence of Joseph Harrison Jr., located at 221 to 229 South Eighteenth Street, was built in 1855. Harrison's fortune was acquired through construction of the Russian railway that stretched from St. Petersburg to Moscow. During World War I, its owner Edward Stotesbury gifted the property to the Emergency Aid Society of Pennsylvania. It was utilized as an army, navy, and marine corps officers' club.

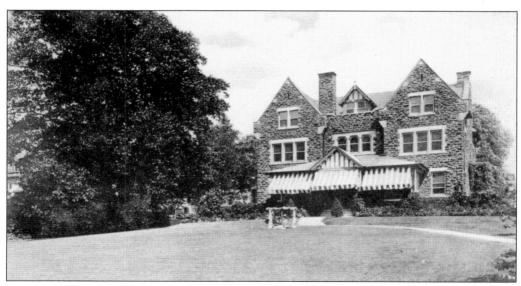

Pelham, an upscale section of Germantown, is bounded by Carpenter Lane, Germantown Avenue, Hortter Street, and Lincoln Drive. The majority of its homes were constructed between 1894 and 1904. This postcard from 1904 shows the magnificent residence of William P. M. Braun at 250 Pelham Road. Braun was listed in the 1905 edition of the *Philadelphia Blue Book*.

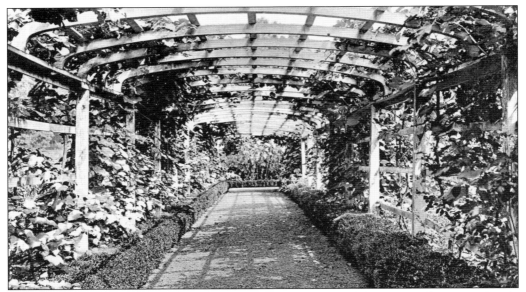

A photographer could not possibly capture the sheer beauty of the grape arbor maturing in Robert Whitaker's garden. His property was situated on East Tabor Road in the Olney section of Philadelphia, and Whitaker was listed as a cotton goods merchant in the 1907 edition of *Gopsill's Business Directory*.

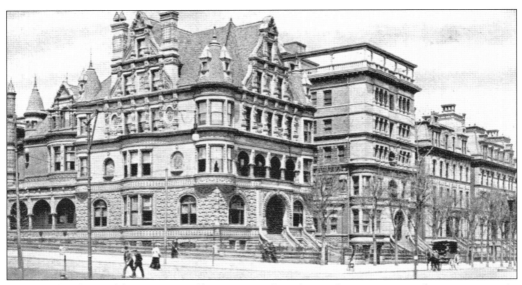

The fabulously wealthy Peter Arrell Brown Widener's vast fortune was made as a partner in the Philadelphia Traction Company and as a founder of the American Tobacco Company. In 1898, Widener donated his "town house," built in 1887 and located on the northwest corner of Broad Street and Girard Avenue, to the Free Library of Philadelphia. It was dedicated as the Josephine H. Widener Memorial Branch. The Wideners then moved to their 110-room mansion in Elkins Park.

Four

WHERE PATRIOTS
HAVE TREAD

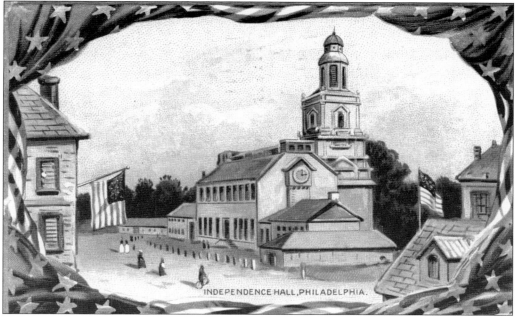

INDEPENDENCE HALL, PHILADELPHIA.

At the time of the American Revolution, Philadelphia was, due to its geographical location, the obvious site to situate the governance of the colonies. Philadelphia later lost the opportunity to become the permanent capital of the United States, and the federal government was moved to Washington in 1800. This card from 1911 depicts a Colonial-era representation of Independence Hall.

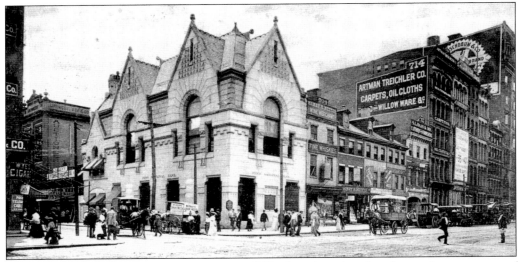

Upon viewing this postcard from 1907, it is difficult to imagine that the southwest corner of Seventh and Market Streets was, in 1776, situated on the outskirts of the city. It was said to be the site of the house where Thomas Jefferson composed the Declaration of Independence. After the house's demolition in 1883, several commercial enterprises, including a bank, were located there. The original Graff House was re-created for the bicentennial of 1976.

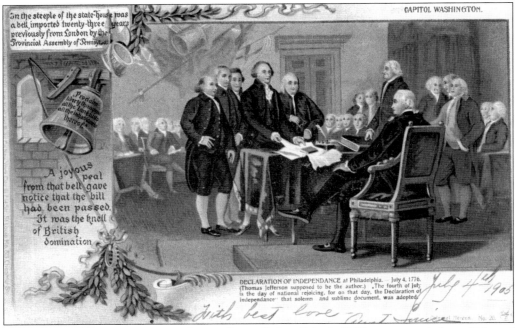

This very ornate patriotic postcard, actually mailed on July 4, 1905, was an artist's rendition of the signing of the Declaration of Independence at Independence Hall.

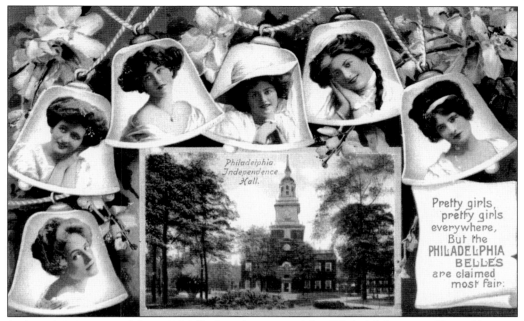

A chauvinistic postcard from 1905 displays the pretty girls of Philadelphia, as well as a Chestnut Street view of Independence Hall. The usage of the term *belles* was not an intentional pun referring to the Liberty Bell but was part of Raphael Tuck's large postcard series entitled "Our Belles."

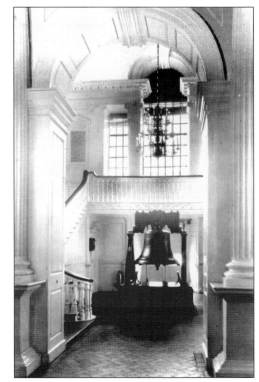

A 1937 photograph by the famous Philadelphia photographer K. F. Lutz visualizes, in a most striking manner, the Liberty Bell, located in the Independence Hall tower vestibule. At that time, the bell was in open view and could be revered and caressed by all.

The Bell Moves at Midnight

December 31, 1975/January 1, 1976

INDEPENDENCE HALL

Sponsored by City of Philadelphia
Independence National Historical Park
Philadelphia '76, Inc.

Seats cannot be guaranteed after 11 P.M.
(THIS TICKET MUST BE VISIBLE AT ALL TIMES)

$1.00 ADMIT ONE

The Liberty Bell was moved at midnight on December 31, 1975, amid great pomp and ceremony, from Independence Hall to Independence Mall. In 2003, it was relocated to the Liberty Bell Center, facing Independence Hall. This ticket of admission commemorated the 1975 event.

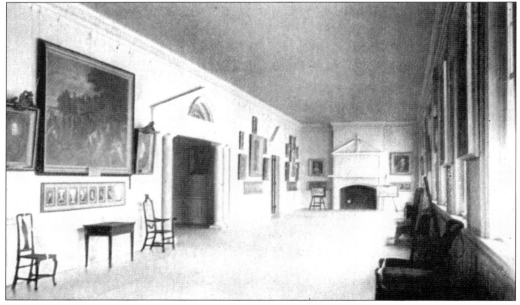

During the first decade of the 20th century, Independence Hall's second floor was open to the public. Originally a banquet hall, it contained chairs belonging to William Penn, portraits of key men of the American Revolution, and the table upon which the Virginia Bill of Rights was written. At one time, it was also home to Charles Willson Peale's museum of natural history.

Independence Hall's main stairway, seen here in 1909, is a remarkable example of Georgian architecture and Colonial workmanship. Benjamin Franklin would have marched up these stairs while governor of Pennsylvania between 1785 and 1788.

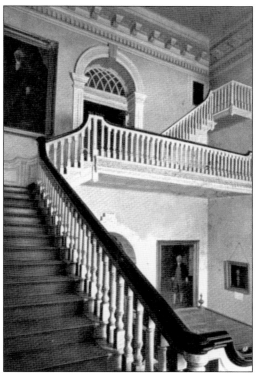

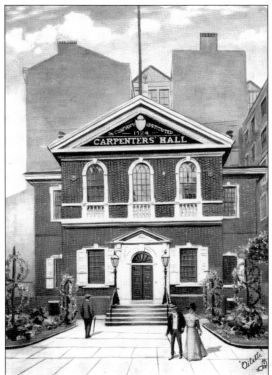

This "Oilette," another in a vast series of Raphael Tuck postcards, depicted the exterior of Carpenters' Hall in 1907. Founded by the Carpenters' Company in 1724, it was erected in 1770 as home to a society of carpenters and architects and is still owned by this guild. The First Continental Congress met here in 1774, and the First Bank of the United States utilized the building from 1791 to 1797.

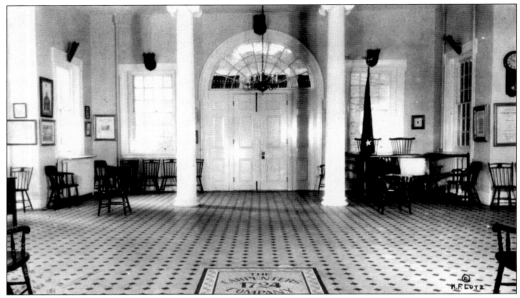

A 1936 view of the Carpenters' Hall meeting room reveals the central portion of its tiled first floor. A number of the hall's original armchairs are displayed in the background.

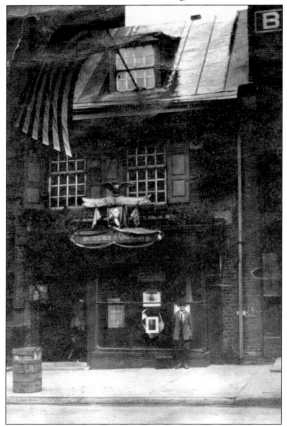

When this photograph was taken in 1918, the Betsy Ross House, the "Birthplace of Old Glory," located at 239 Arch Street, was in a pitiful, sagging state. Built in the Georgian style around 1740, the tiny nine-room house was rented to Betsy and John Ross, who lived there from 1773 until 1786.

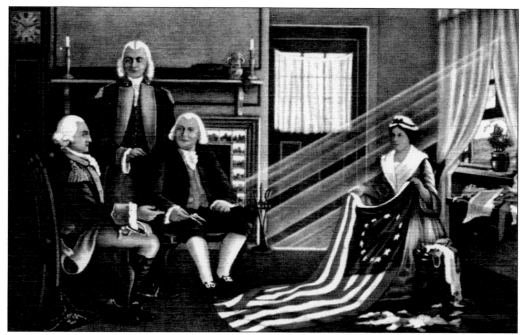

Artist Charles H. Weisgerber painted this rendition of the birth of the nation's flag, when George Washington, George Ross, and Robert Morris (from left to right) met with Betsy Ross in what was later named the Flag Room. The postcard was printed in the 1940s.

In 1898, two million contributors donated their dimes for the restoration of the American Flag House and Betsy Ross Memorial. In 1937, A. Atwater Kent provided $25,000 (around $358,000 in 2007 dollars) for further improvements. In the previous postcard, the front door was located on the right side of the room. In this post-restoration view from 1955, the front door has been moved to the opposite side of the wall.

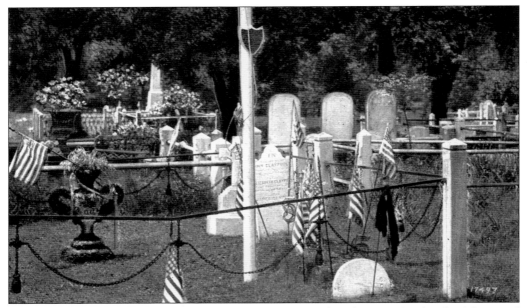

When Betsy Ross died in 1836, her remains were interred in the Free Quaker burial ground on South Fifth Street, not far from her Arch Street home. In 1856, her body was moved to Mount Moriah Cemetery in southwest Philadelphia, seen in this postcard from 1930. During the American bicentennial of 1976, she was again reburied at the Betsy Ross House.

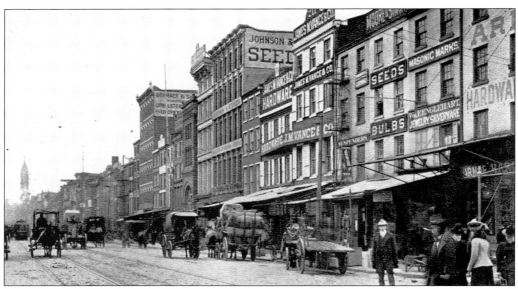

In 1905, the north side of Market Street between Second and Third Streets was a veritable beehive of business activity. The building in the center of this postcard, the Johnson and Stokes Seed Store, remains standing today. The stores to its right were later demolished, and Christ Church could then easily be seen from Market Street.

Christ Church, located at 22 to 26 North Second Street, was the first Protestant Episcopal church in the colonies. Constructed between 1727 and 1744, it has always been an awesome example of Colonial Georgian architecture. A *c.* 1900 bird's-eye view was taken from a building loft on the opposite side of North Second Street.

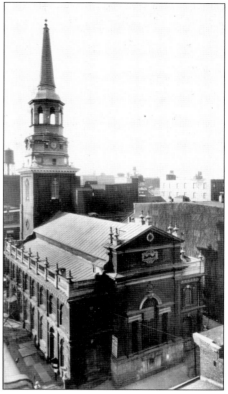

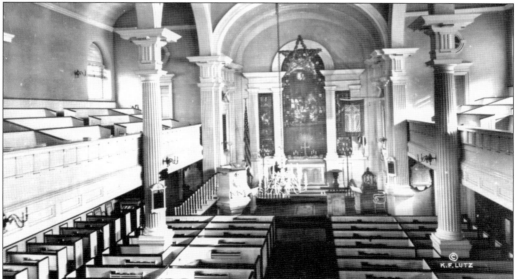

Seen in 1937, the interior of Christ Church, with its high fluted columns and wooden pews, has remained unchanged since Colonial times. During the Revolutionary War, members of the church's congregation included many legendary patriots, such as George and Martha Washington, who had occupied pew number 58. Benjamin Franklin and his family reserved pew number 70.

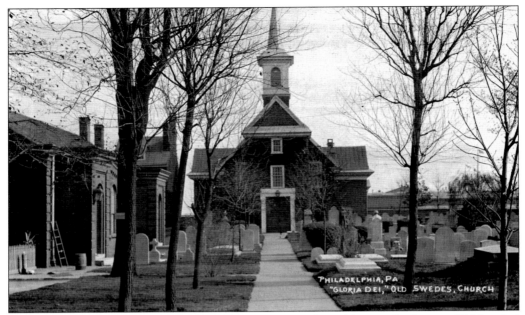

The Swedes who had settled near the Delaware River in the 1630s were Lutherans. Old Swedes' Church, also known as Gloria Dei, built around 1700, was converted to Episcopalianism in 1845. The church's facade, a stunning example of 17th-century Swedish architecture, is seen in this 1905 real-photo view. The church and its ancient graveyard remain today at Columbus Boulevard (formerly Delaware Avenue) and Christian Street in the Southwark district of Philadelphia.

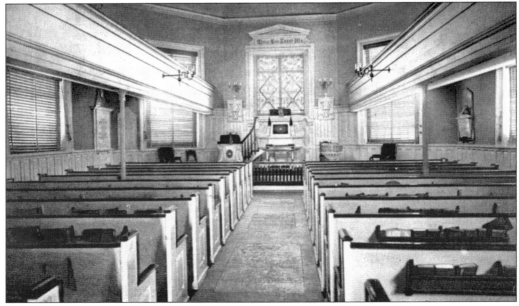

This interior view of Old Swedes' Church was mailed in 1908. The upstairs galleries were added in 1846, the ground floor pews updated in 1902, and a pipe organ was imported from Germany in 1846. The church was listed on the National Register of Historic Places in 1966.

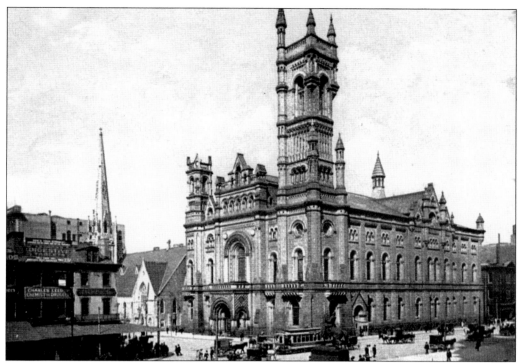

The Masonic temple, located on North Broad Street adjacent to city hall, is short for the Right Worshipful Grand Lodge of the Most Ancient and Honorable Fraternity of Free and Accepted Masons of Pennsylvania. Words cannot adequately describe the edifice's colossal grandeur, seen in perspective in this postcard from 1905. Completed in 1873, it was designed in the Romanesque style by James H. Windrim.

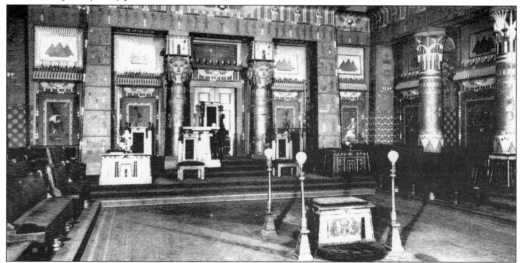

Twelve huge columns dominate the four corners of the Masonic temple's Egyptian Hall, which was completed in 1889. The worshipful master's throne of gilded ivory, seen front and center, was surrounded by sphinxes. The hieroglyphics that graced the hall were accurately hand painted. The card was postmarked in 1905.

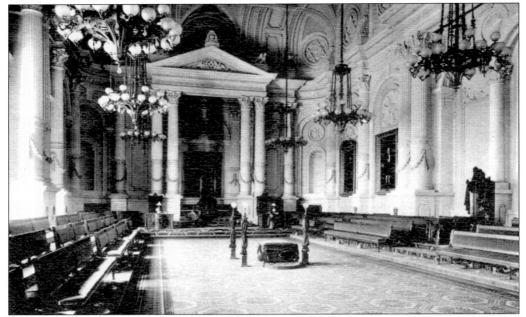

Corinthian Hall, as it appeared between 1873 and 1903, is seen in this 1905 postcard. It was decorated with mosaics based on Greek mythological scenes and emblazoned with gilded reproductions of ancient coins and medallions set in bas relief. The hall is currently the meeting place of the Grand Lodge of Pennsylvania.

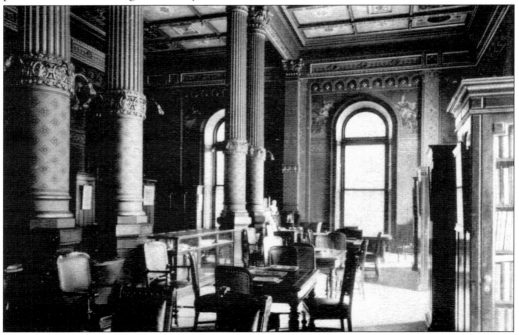

The temple's museum and library still contain one of the world's finest collections of rare Masonic books and artifacts, including George Washington's and Benjamin Franklin's ceremonial Masonic aprons.

Five

Amusement Parks, Midways, and Gladways

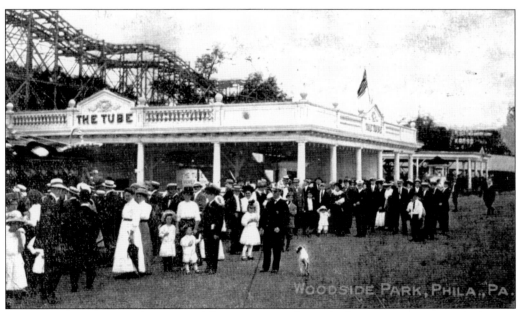

Woodside Park, seen in this postcard from 1912, was located adjacent to Fairmount Park, near the intersection of Monument Road and Conshohocken Road. It was in operation from 1897 until 1955. It was best known for its wooden roller coasters, the oldest having been erected in 1925. In this scene, well-dressed riders were patiently queued to ride the Tube.

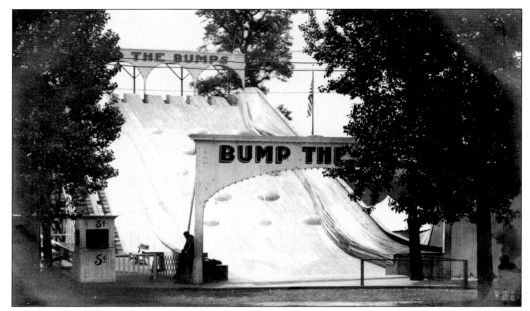

In 1908, for the price of one nickel (around $1.15 in 2007 dollars), a visitor at Woodside Park could ride the giant slide aptly named the Bumps. The convex bumps on the slide's surface did not appear overly derriere-friendly.

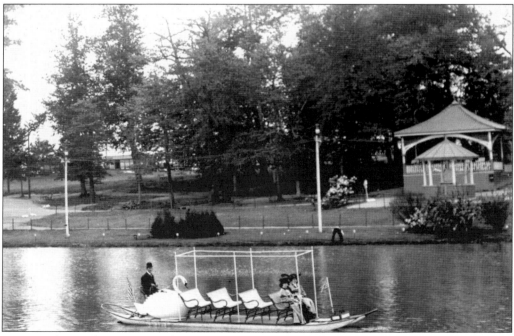

Motorized swan boats were a pleasant way to cool off on a warm summer Sunday afternoon.

Patrons could also rent canoes. The Woodside Park waterways and large man-made lake were both an invigorating and a healthy means of exercise for city dwellers. Hopefully, the gentleman in this boat had ducked his head before approaching the low bridge.

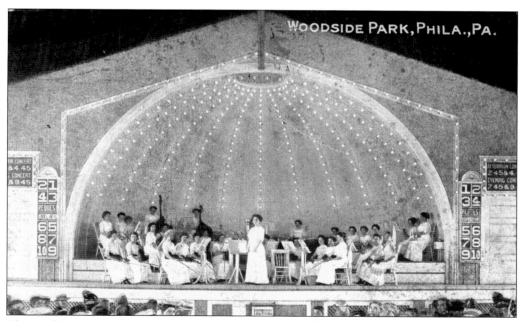

The park's music hall accommodated large crowds. This postcard from 1914 showed an all-female orchestra playing to a large audience. Showtimes were listed on the signage on the far left.

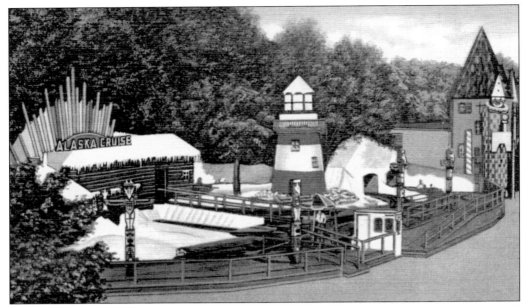

As amusement park technology increased, rides became more sophisticated. Woodside Park had many attractions for adults, and Kiddie Land provided fun for the youngsters. This undated postcard, probably from the 1940s, displayed the children's ride Alaska Cruise.

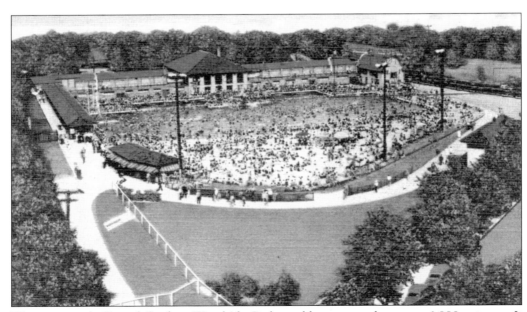

The mammoth Crystal Pool at Woodside Park could accommodate over 6,000 patrons. It boasted a spacious sandy beach, a large wading pool, and a separate swimming and diving basin, as well as a water slide. This postcard was also probably from the early 1940s.

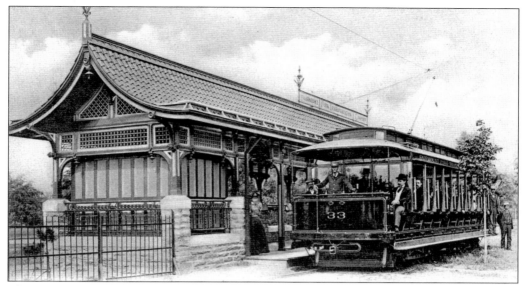

The Fairmount Park Transit Company was in operation from 1894 until 1946. The transit company purchased open-air cars—such as that seen in this postcard—for summertime use and closed cars as well, from Philadelphia's J. G. Brill Company. The trolleys ran in a continuous loop from the Parkside Avenue terminal to Chamonioux Station (near City Line Avenue) and back.

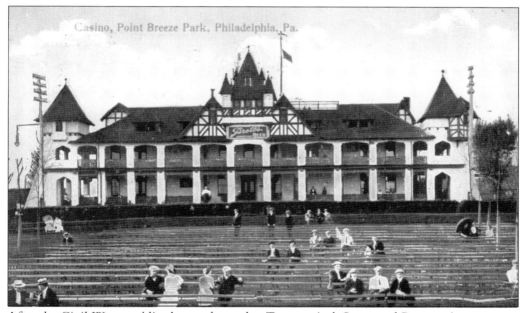

After the Civil War, a soldiers' camp located at Twenty-sixth Street and Penrose Avenue, near the present site of the Philadelphia International Airport, was transformed into Point Breeze Park. The park was noted for its racetrack, and many famous steeds had thundered around its dirt raceway. This is a 1914 view of the casino.

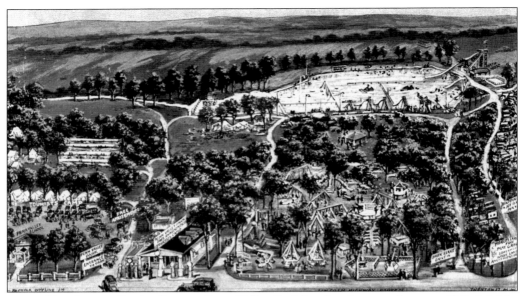

Located in Trevose, Bucks County, Penn Valley Park bordered on northeastern Philadelphia. In 1934, it was a long journey travelling along the Roosevelt Boulevard to its continuation, the Lincoln Highway (U.S. Route 1), and on to the hinterlands of Bucks County. Penn Valley Park was touted as the largest free amusement park in the world. It boasted campgrounds, a massive pool, and many children's activities.

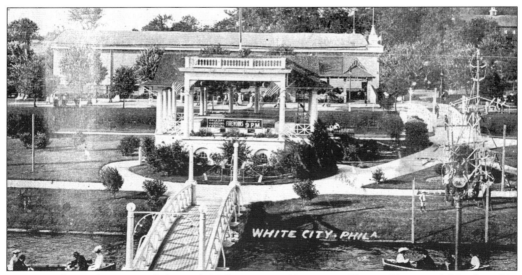

Between the mid-1800s and the mid-20th century, Chestnut Hill, an affluent neighborhood in northwestern Philadelphia, was considered both a railroad suburb and a streetcar suburb, and the owners of the Germantown Avenue trolley line strived to increase its weekend ridership. In 1898, that goal was achieved when Chestnut Hill Park, located at the terminus of the Germantown Avenue trolley, opened for business. This view was taken eight years later.

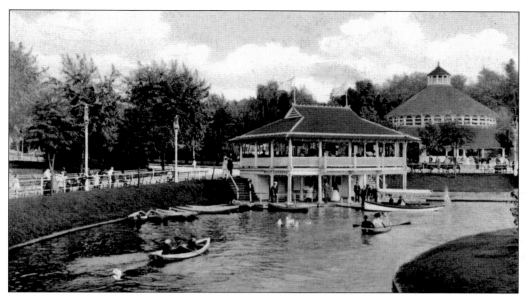

Since all the buildings were painted white, the park was also called White City, after the name given to the Chicago Columbian Exposition of 1893. The entrance was but a short stroll from the trolley terminus, and no admission fee was levied at the main gate. Once inside, however, customers paid for individual rides. This postcard from 1910 shows the white boat pavilion.

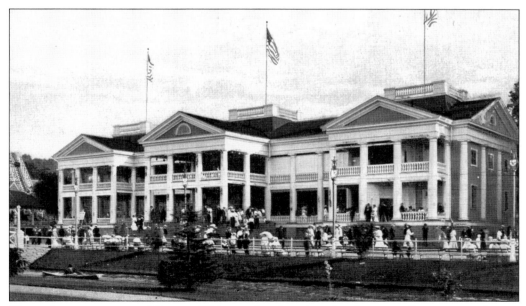

The casino was not a gambling establishment but functioned as the center for concerts, dances, and amusements. Its majestic white columns could be viewed from the other side of the park. It is seen here in a picture taken in 1908.

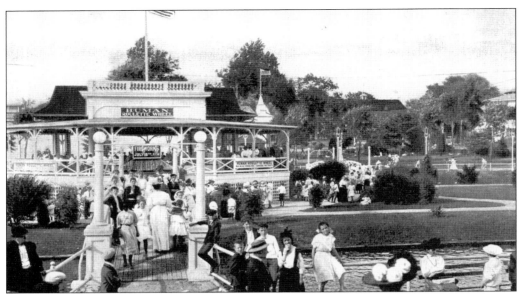

During the summer of 1907, the *North American* newspaper advertised "North American Day" and printed free ride coupons on its front page. A young writer scribbled on the reverse of this postcard, "This is the famous White City park that you read about in the North American." It was probably not a great idea to eat a heavy meal before riding on the Human Roulette Wheel.

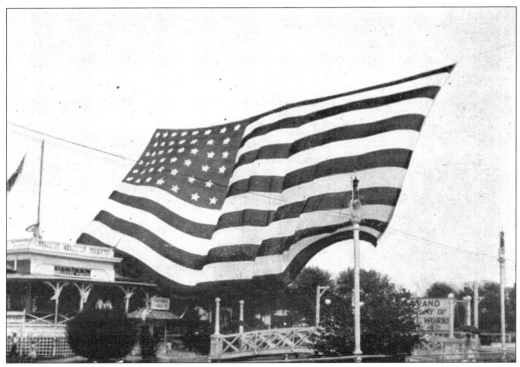

Chestnut Hill Park boasted the world's largest American flag. The 45-star flag was raised on June 14, 1911, being 70 feet high and 135 feet long.

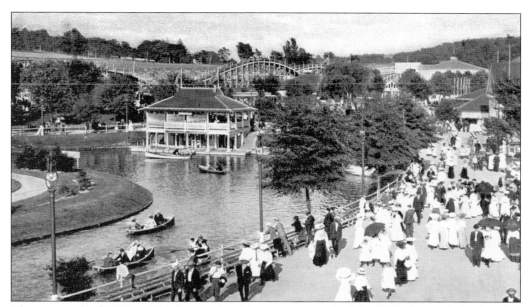

The east end of White City is seen in this card postmarked in 1916. Beyond the boating pavilion is the giant wooden toboggan, which was later known by its more popular name, the roller coaster.

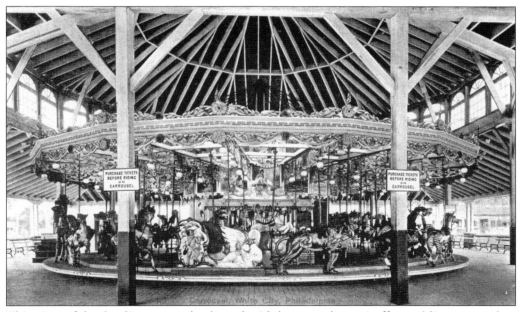

This view of the dazzling carousel, adorned with horses, zebras, giraffes, and lions, was taken in 1909. White City was closed after only 13 years, since its nearby residents deplored the "riffraff" that frequented their Chestnut Hill neighborhood.

Old York Road, originally a toll road maintained by the Philadelphia Rapid Transit Company (PRTC), was deprivatized in 1918 and became part of the Pennsylvania state highway system. In 1907, a single lonely automobile and a PRTC trolley heading toward Willow Grove were sighted along the Oak Lane portion of Old York Road.

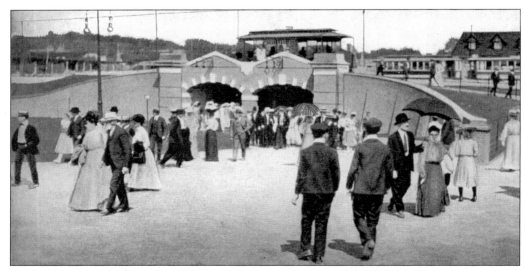

Willow Grove Park opened in 1895 as a 100-acre picnic grove. Philadelphia folks, eager to leave the cluster and heat of the city, jumped on the PRTC trolleys and flocked beneath the park's shady trees. The picnic grove was soon transformed into an amusement park. In 1905, crowds passed through its trolley entrance to the main transportation center outside the park.

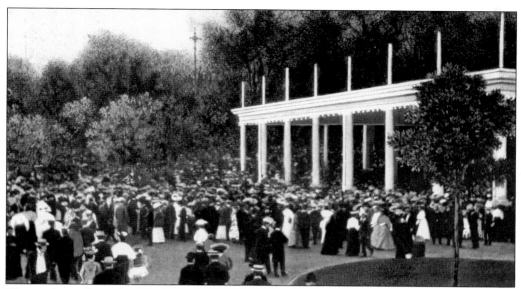

The music pavilion, the greatest attraction in the park, is seen in this 1905 view. Victor Herbert, who composed "Babes in Toyland" while in residence at the park, and John Philip Sousa were its world-renowned headliners.

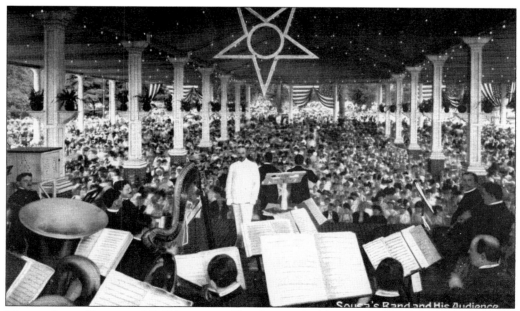

Sousa's Band and His Audience

The music pavilion seated 5,000 persons. Ten thousand additional listeners could be seated on the lawns and by the lake. In this unbelievable view from 1910, there was not a seat to be had, as John Philip Sousa readied his concert band. The pavilion was demolished in 1959.

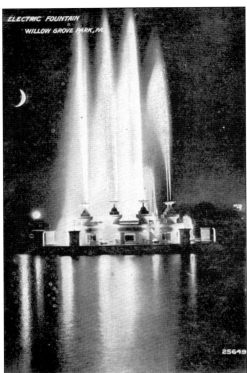

By day, this four-acre lake was filled with well-dressed patrons drifting about leisurely in rented rowboats. After sunset, the lake's magnificent fountain was splendidly transformed into a veritable rainbow, illuminated by more than 50,000 multicolored electric bulbs.

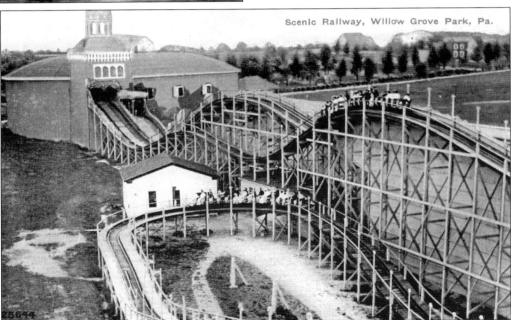

The scenic railway, Ferris wheel, two carousels, other minor rides, and over 100 amusement concessions filled the park in 1905. During and after World War I, the park's glory rapidly faded. It continued in operation until 1975, the grounds lying fallow for several years, until Willow Grove Park, now the name of an enormous shopping mall, was opened in 1982.

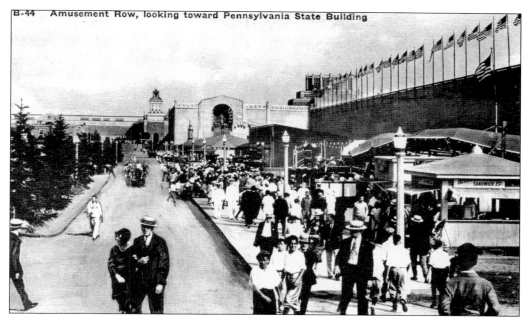

During the planning phase of the sesquicentennial exposition of 1926, its directors proposed that a portion of the exhibition grounds be reserved for public amusements. The Gladway was situated on the west side of Broad Street, just south of Packer Avenue. It was mandated that attractions and concessions located therein be unquestionably unobjectionable to people of refined tastes.

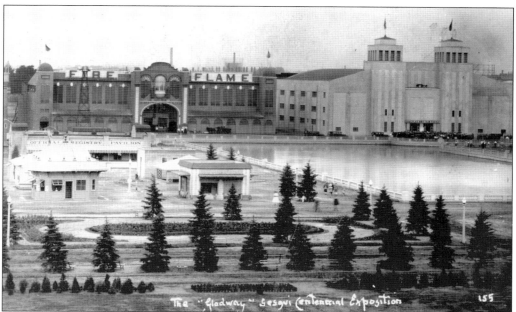

The Gladway was comprised of 28 amusements and sports, as well as a myriad of restaurants, exhibitors' buildings, and a doll market. "Fire and Flame," seen in this birds'-eye view of the Gladway, was the New York City fire department's visual presentation of the manner in which it had bravely fought a raging fire in the bowery.

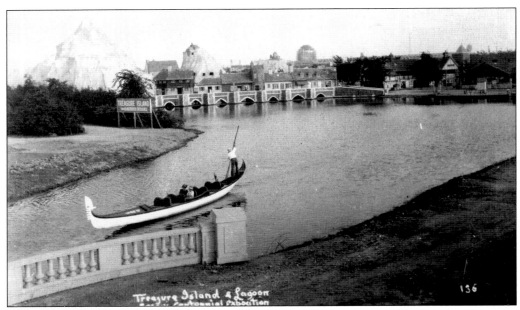

The largest concession was Treasure Island, consisting of a mock-up of the Canadian Rockies (seen in the background), a railroad train that toured the exhibition grounds, and a Disneyesque story land populated with live costumed fairy tale characters. Gondolas, such as the one in the foreground, imported from Italy, floated across Edgewater Lake. The authentic Italian gondoliers were also singing boatmen.

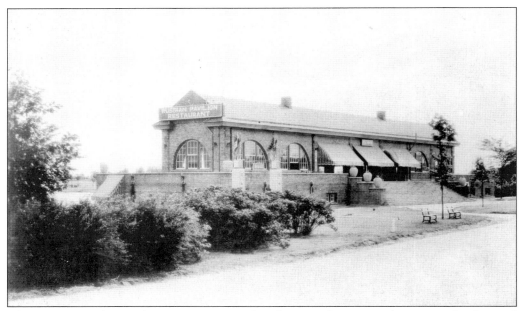

The Russian Pavilion and Tea Room, situated in the canoe house on Edgewater Lake, featured food, dancing, and a balalaika orchestra. The building remains standing today, having been revitalized by architect David S. Traub.

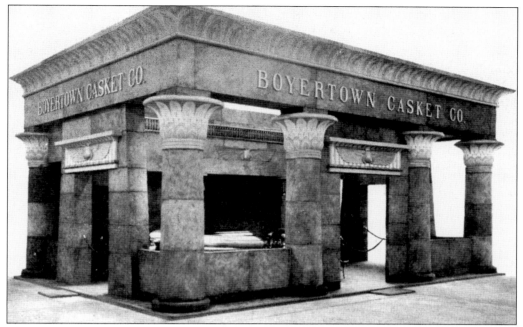

The Boyertown Casket Company's factory, located in Berks County, had Philadelphia showrooms at 1211–1217 Arch Street. In 1926, its exhibit booth, designed in an Egyptian motif and decorated with scarab beetles, was featured in the sesquicentennial exposition's Palace of Liberal Arts and Manufacturers. At the time of the 150th anniversary of the nation, this exhibit certainly made one contemplate one's own mortality.

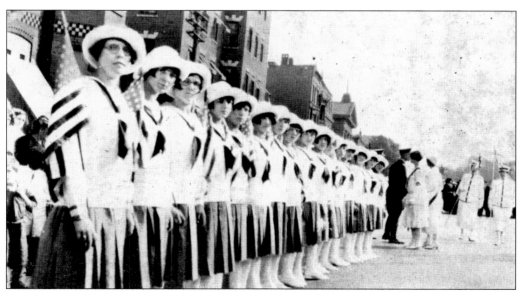

The League Island Navy Yard was located adjacent to the sesquicentennial grounds. The lovely Girl Cadets of the Odd Fellows Home are seen in formation in front of the navy yard's administration building, doing whatever it was that they were supposed to be doing.

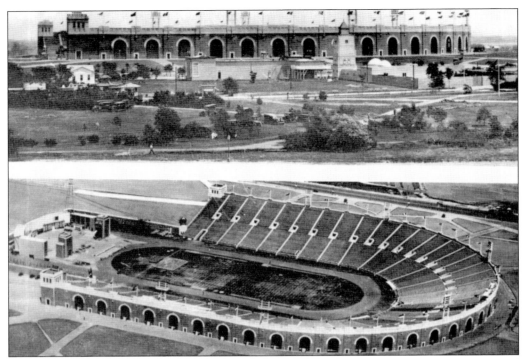

The two-million-dollar concrete Municipal Stadium, seen here in twin views, was constructed primarily for sesquicentennial exposition events, although the long-range plan was for it to remain as a permanent structure. The crowd capacity was 100,000, with 73,830 bleacher seats. In 1926, it functioned as a sports arena and was also the site of a gargantuan pageant entitled "Freedom," involving 1,200 cast and organization members.

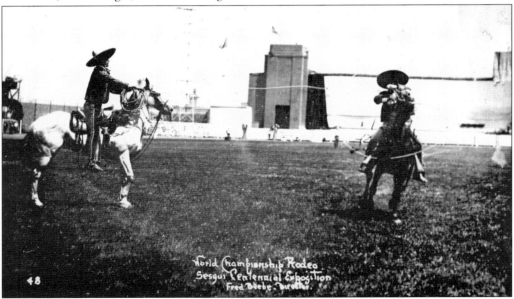

Seen here is a snapshot taken at the stadium's 1926 world championship rodeo. Was one cowboy attempting to lasso the other?

Six

THE RIGHT TO ASSEMBLE

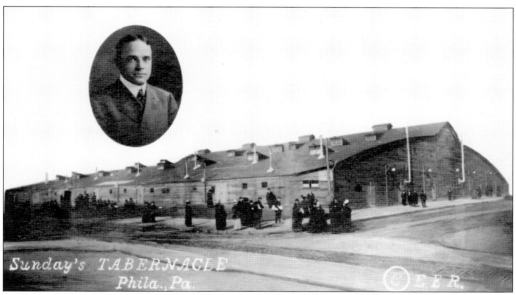

William (Billy) Ashley Sunday (1862–1935) was an evangelist who preached fundamentalist doctrines to his many congregations throughout the United States. His wooden Philadelphia Tabernacle was located at Nineteenth Street and Vine Street. Sunday delivered his sermons in a colorful, homespun manner, and to the delight of his audience, had even smashed a few chairs onstage. The tabernacle is seen here in a view from 1915, with an inset photograph of Reverend Sunday.

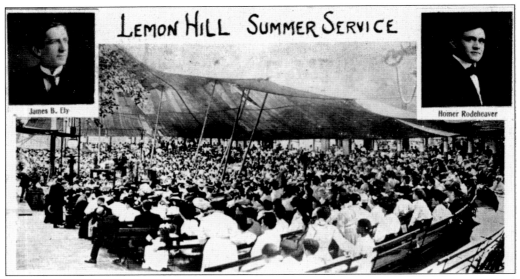

The music pavilion in Fairmount Park's beautiful Lemon Hill was the scene of this evangelical summer service in September 1908. Rev. James B. Ely, an outspoken Philadelphia preacher, railed to his audience about the perils of alcohol. Homer Rodeheaver, an accomplished trombonist, was a natural showman and "warmed up" the audience for Reverend Ely. Rodeheaver was also Billy Sunday's music director from 1910 until 1930.

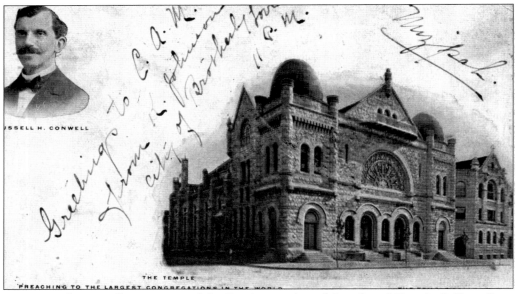

Rev. Russell Conwell was pastor of the Baptist temple and founder of Temple College (later Temple University). Designed by architect Thomas Lonsdale, the Baptist temple was completed in 1893, its granite facade in the Romanesque style. On the card's far right can be seen a glimpse of the original Temple College building. This card was postmarked in 1901.

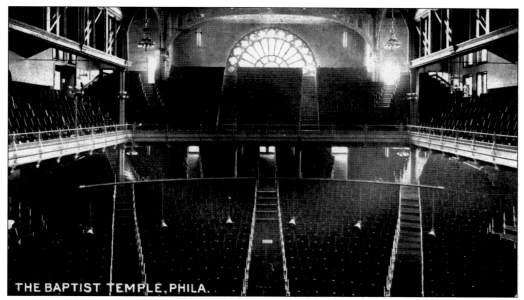

The grand interior of the Baptist temple was photographed in 1911. Its seating capacity was 3,000, and the roof was supported by massive 90-foot trusses. In the mid-1980s, the building was closed due to failure of these trusses. Temple University plans to renovate this historic building into a state-of-the-art performance hall.

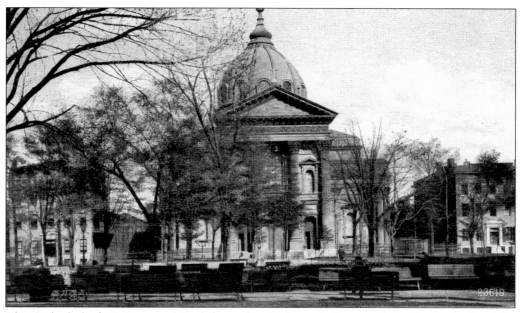

The Cathedral of SS. Peter and Paul, located at Eighteenth Street and the Benjamin Franklin Parkway, is the seat of the archdiocese of Philadelphia for the Roman Catholic Church. Erected in 1864 in the midst of the Civil War, the brownstone edifice, seen here in a photograph from 1917, was designed in the Roman Corinthian style and modeled after the Lombard Church of St. Charles in Rome.

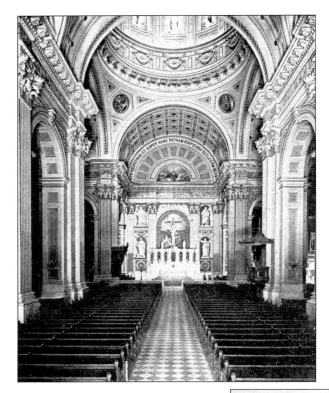

Seating 2,000, the interior of the Cathedral of SS. Peter and Paul is reminiscent of the great churches of Europe. Seen in this postcard from 1905, the artwork was predominantly executed by Constantino Brumidi, whose paintings also grace the Capitol dome in Washington, D.C.

St. Peter's Protestant Episcopal Church, located on the southwest corner of Third Street and Pine Street, was erected between 1758 and 1761 and was a branch of Christ Church (see page 47), having shared the same rectors until 1832. George Washington, Benjamin Franklin, and Gov. Richard Penn had often attended services here. The austere tower and spire, apparent in this 1901 view, rises to a height of five and a half stories.

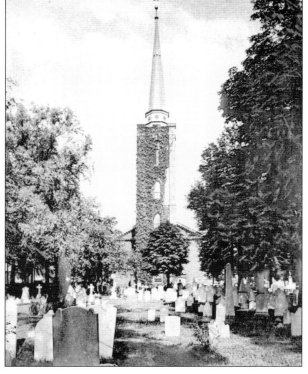

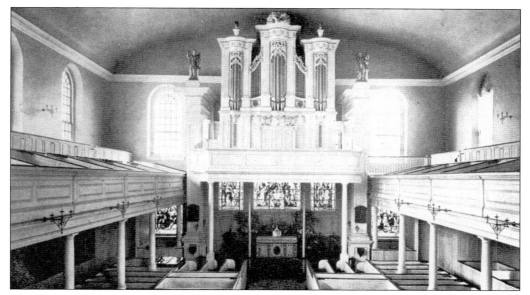

The interior of St. Peter's Protestant Episcopal Church was captured in this 1905 view. The large Palladian stained-glass windows containing 237 panes were obscured by the massive pipe organ. Since the organ and altar were located at the eastern end of the church, and the pulpit and reading desk at the western end, both the rector and the congregation had to shift their positions during the service.

St. Joseph's Church, erected in 1733 and rebuilt in 1838, remains the oldest Roman Catholic church in Philadelphia. The church was purposefully built to resemble a house, since English law had prohibited erection of a Catholic church. Located just off South Third Street in Willing's Alley, it is seen in this *c.* 1940 postcard.

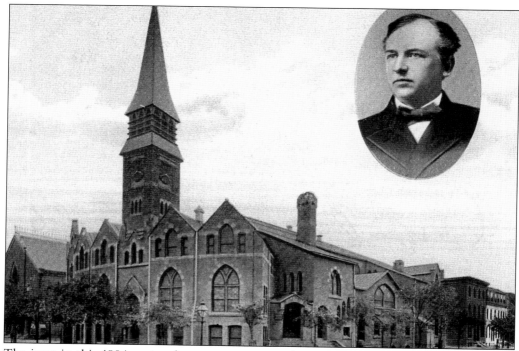

The inset in this 1904 postcard portrays a young John Wanamaker and features his beloved Bethany Church. The devout Wanamaker claimed that religion was more important to him than his businesses. The Presbyterian church, located on the corner of Twenty-second Street and Shippen (now Bainbridge) Street, was dedicated in 1868. Built in the Scandinavian style, it boasted a 105-foot spire and a 350-seat lecture hall.

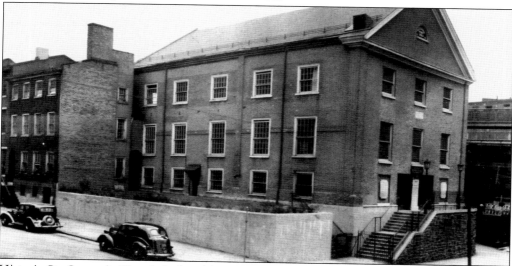

Historic St. George's Church is the oldest functioning Methodist church in existence, having been occupied since 1769. Located at 235 North Fourth Street, under the shadows of the Benjamin Franklin Bridge in the Northern Liberties section of Philadelphia, the church and church house were photographed in 1937. The first African American Lay Preachers of Methodism, Richard Allen and Absalom Jones, were licensed here in 1785.

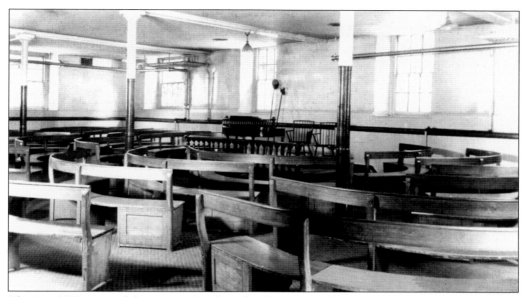

This is a 1937 view of the austere Sunday school room in old St. George's Methodist Church.

Temple Keneseth Israel synagogue was located on Broad Street above Columbia Avenue, on what is now the Temple University campus. Erected in 1892, the reformed congregation was founded by Rabbi Joseph Krauskopf, who required that the campanile be a replica of the church in Venice's St. Mark's Square and the dome be modeled after the Mosque of Omar in Jerusalem. In 1957, the congregation relocated to Elkins Park.

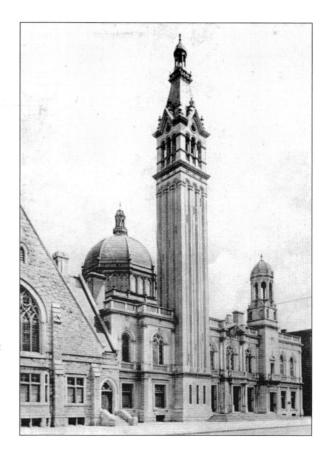

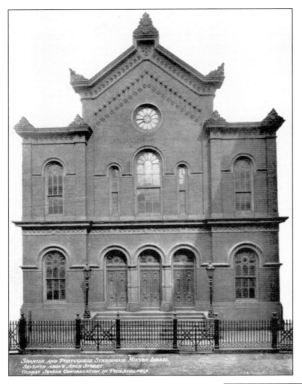

Jews have lived in America since the time of William Penn, and Jewish patriots helped finance the American Revolution. Mikveh Israel's first synagogue building was established in 1762. This postcard from 1907 highlights the synagogue's third location at Seventh Street and Arch Street. Designed by John McArthur Jr., architect of Philadelphia's city hall, it supported a congregation of Spanish and Portuguese Jews.

Rodeph Shalom Synagogue was founded in 1802. The building in this 1904 postcard was located at Broad Street and Mount Vernon Street. When construction of the northern portion of the Broad Street subway was announced, the synagogue's leaders voted to remain at their same location. After the building's demolition in 1926, another synagogue was erected on the site in 1927.

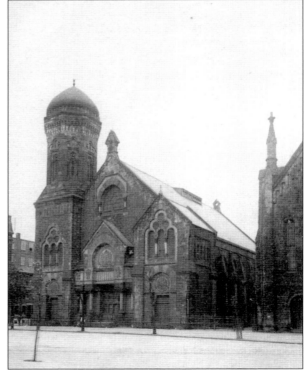

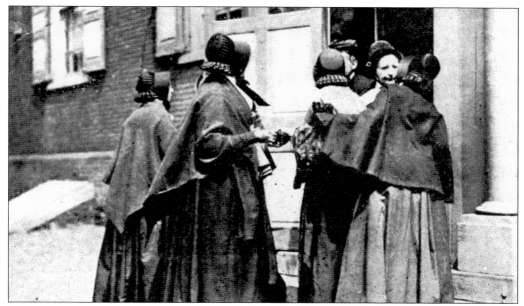

The Society of Friends, also known as the Quakers, fled to America in pursuit of religious freedom. In 1681, the English King Charles II settled a debt owed to William Penn's father by granting to him the huge tract of land that was designated as Pennsylvania. Philadelphia became the "Quaker City," and Quaker meeting and business houses abounded. This 1905 view shows a group of Quaker women on their way to meeting.

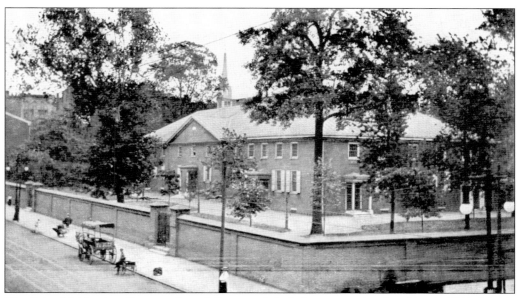

The Friends' Meeting House at Fourth Street and Arch Street remains the oldest in Philadelphia and the largest such building in the world. It was constructed between 1804 and 1811 by master carpenter Owen Biddle and was fashioned according to the Quaker principle of simplicity.

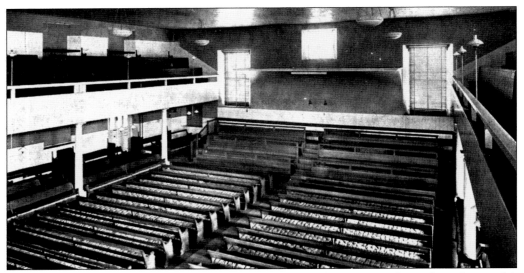

An interior view of the Arch Street Meeting House was taken peering down from the youth's gallery. At one time boys and girls were required to use separate staircases. However, the building is now shared by both men and women. The women's yearly meeting was held in this room from 1811 until 1920. The hard wooden pews reflected the Quaker doctrine of plainness.

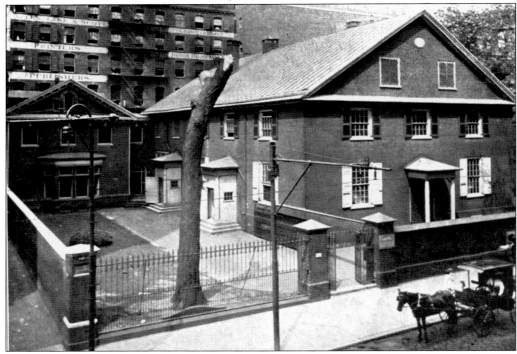

The Friends' Meeting House at Twelfth Street below Market Street no longer exists. Built in 1813 in what was eventually to become the central business district of Philadelphia, it was—by 1970 Quaker standards—no longer necessary. The building was dismantled, bricks and timbers alike, and in 1974 was reassembled on the campus of the George School, a Quaker boarding academy in Bucks County.

Seven

CROWD PLEASERS

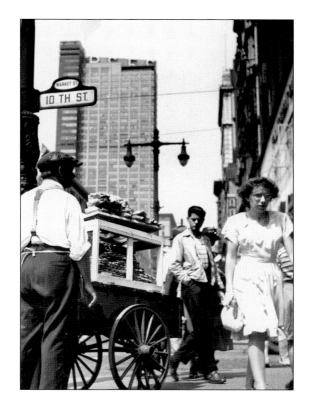

Pretzel peddlers were a common site in
Center City. As long as one overlooked
the unsanitary aspects of their wares,
a Philadelphia pretzel has always been
a delicious treat. This photograph was
taken at Tenth Street and Market Street
in 1945.

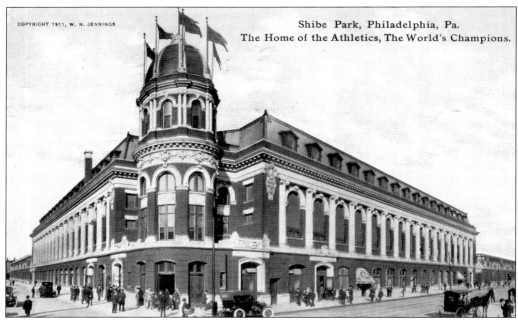

Shibe Park, Philadelphia, Pa.
The Home of the Athletics, The World's Champions.

Shibe Park, located between Twentieth and Twenty-first Streets and Lehigh Avenue, opened in 1908, constructed at a cost of $654,000 (about $15.9 million in 2007 dollars). This 1911 view of the stadium proudly announced that it was home of the Philadelphia Athletics, winners of nine American League championships and five World Series. Connie Mack, team manager from 1901 through the 1950 season, eventually retired at age 87. In 1953, Shibe Park was renamed Connie Mack Stadium in his honor.

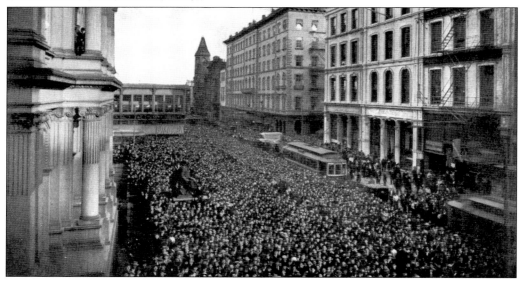

The *Philadelphia Record*, one of the city's major newspapers, was located on Ninth Street near Chestnut Street. An electric scoreboard installed on the building's exterior registered up-to-the-minute sports scores. In 1910, the scoreboard created a massive gridlock as spectators, with great anticipation, watched the World Series results. The Philadelphia Athletics defeated the Chicago Cubs, and in the series' last game, the Athletics won by an astounding 35 to 15.

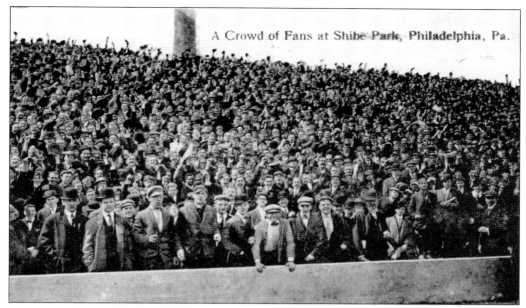

A Crowd of Fans at Shibe Park, Philadelphia, Pa.

Every seat in Shibe Park was filled when this snapshot was taken in 1910. In the years following the advent of radio, and eventually television broadcasts, attendance at baseball games slipped, since fans could now be entertained in the comfort of their living rooms. "Take Me Out to the Ball Game," written in 1908 by Jack Norworth, became the third-most-sung song in America.

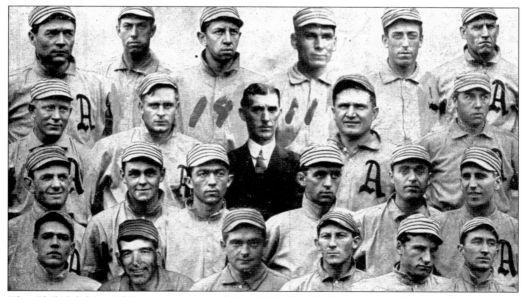

The Philadelphia Athletics, winners of the 1911 World Series, beat the New York Giants four games to two. Although a portion of this card's lower border had been mutilated, the decipherable names in the top row (from left to right) are Harry Davis, Jack Coombs, Albert "Chief" Bender, Eddie Plank, and Cy Morgan. Connie Mack, attired in his customary jacket and tie, can be seen in the center.

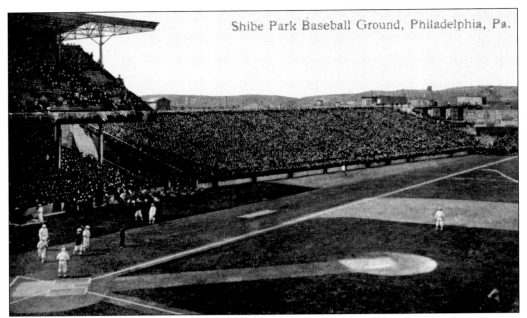

During this 1912 season game, the bases may not have been loaded, but the grandstands were most certainly filled to capacity.

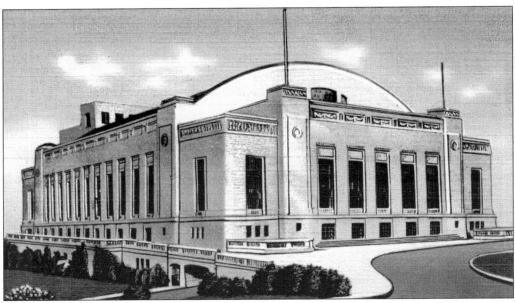

Municipal Auditorium, later renamed Convention Hall, was located on the campus of the University of Pennsylvania. Built in 1930, it served as an all-purpose arena where crowds cheered the Ice Capades, Philadelphia Mummers' Show, Philadelphia 76ers, and the Beatles. Both Democratic and Republican national conventions were televised here in 1948. It was demolished in 2005 to make way for a new university medical center. This postcard is from the 1940s.

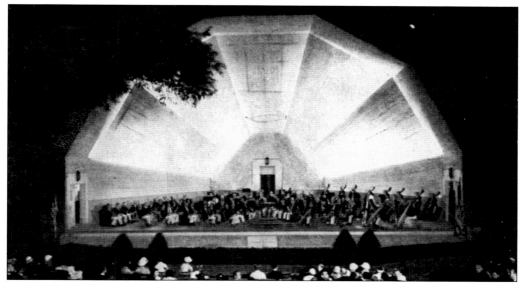

The Robin Hood Dell, located near the East River Drive in Fairmount Park, opened to the public in the summer of 1930. Eugene Ormandy, later the conductor of the Philadelphia Orchestra, made his debut in July 1930. This card, date unknown, provides a close-up view of its acoustic music shell. The facility was named after the 1735 site of the Robin Hood Tavern, located near the Schuylkill River.

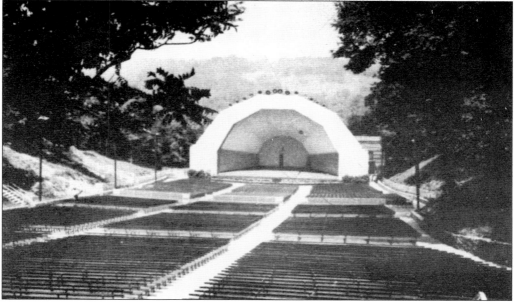

In 1948, the energetic Philadelphia businessman Fredric R. Mann assumed the presidency of the Robin Hood Dell Association. His "Philadelphia Plan" was a great success, broadening audience exposure to classical music by providing free tickets for the Philadelphia Orchestra's summer concert series. The breathtaking vista of Fairmount Park can be seen in the background.

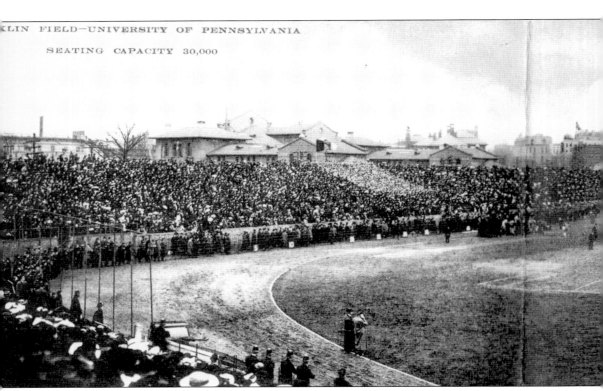

KLIN FIELD—UNIVERSITY OF PENNSYLVANIA

SEATING CAPACITY 30,000

A large portion of Franklin Field, situated on the campus of the University of Pennsylvania, can be seen in this 1902 view. The stadium opened in 1895, with a seating capacity of 30,000, for the premiere running of the Penn Relays. The original wooden bleachers were removed in the 1920s. The lower-level bleachers were replaced in 1922, and the second tier added in 1925, increasing the seating capacity to 59,293. From 1958 to 1970, the stadium was

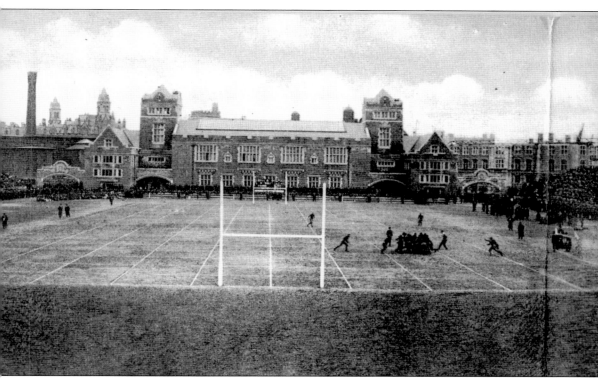

home to the Philadelphia Eagles, and in the 1960 National Football League championship game, the Eagles beat the Green Bay Packers 17 to 13. The field was host to the army-navy football games from 1899 until 1935. Municipal Stadium, constructed in 1926 (see page 66), was utilized for these games until 1992, when that structure was demolished.

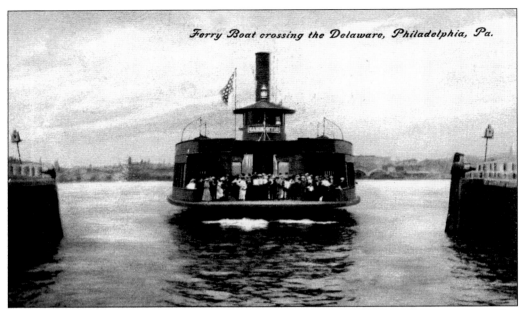

Ferry Boat crossing the Delaware, Philadelphia, Pa.

The Pennsylvania Railroad ferry terminal was located at the Delaware Avenue and Market Street pier. In 1909, when this postcard was issued, the ferry was a preferred route for passengers and their vehicles to reach Camden, New Jersey, and from there to the New Jersey seashore. In 1926, after the Delaware River (now Benjamin Franklin) Bridge was built, ferry usage was greatly reduced. The service was suspended in 1952.

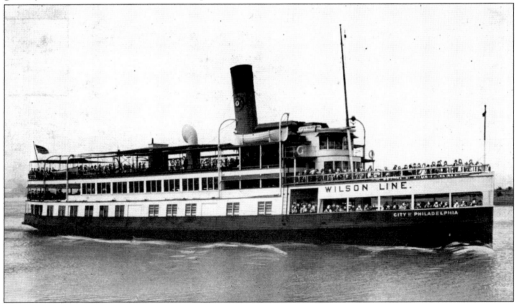

Daily and moonlight sightseeing trips on the Delaware River have always been a popular attraction. The Wilson Line operated boats between Philadelphia, Chester, Wilmington, Delaware, and Riverview Beach Park in New Jersey. The steamer *City of Philadelphia*, seen in this photograph, was added to its fleet in 1910. The service was discontinued in 1961, which signaled the death knell for Riverview Beach Park.

The Delaware River provided outdoor water sports for the more affluent. Numerous smaller private vessels are seen weaving about the river in this scene from 1905.

The Camden, New Jersey, approach to the Delaware River Bridge is captured in this view, shortly after the bridge opened in 1926. Even in its infancy, the bridge was a bottleneck to traffic entering and leaving Philadelphia. The bridge remains as a vital link between Philadelphia and New Jersey.

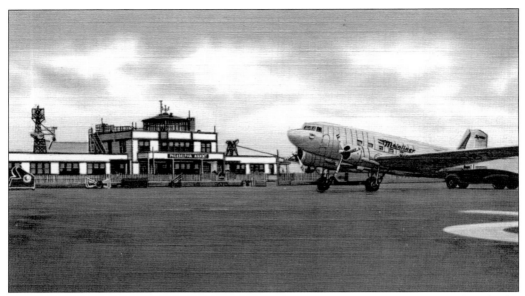

The Philadelphia Airport, later known as Municipal Airport, was dedicated in 1927 by Charles Lindbergh. This 1940s postcard reveals the airport's Lilliputian tarmac and control tower. In the 1960s, the words *skyjack*, *sky marshal*, and *homeland security* were unknown in the travelers' lexicon. At that time the airport was open to the public, and plane watching was an inexpensive way to spend a pleasant Saturday evening.

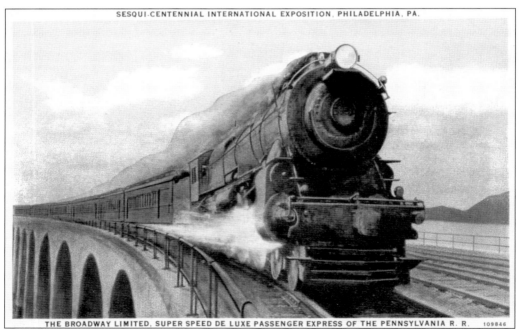

SESQUI-CENTENNIAL INTERNATIONAL EXPOSITION, PHILADELPHIA, PA.

THE BROADWAY LIMITED, SUPER SPEED DE LUXE PASSENGER EXPRESS OF THE PENNSYLVANIA R. R. 109846

In 1926, there was no better means of transportation for out-of-towners to reach Philadelphia than via the Pennsylvania Railroad's Broadway Limited, which made its daily 18-hour run from Chicago to Philadelphia. The name Broadway was not based on New York City's famous thoroughfare but described the broad four to six sets of rails on which the trains travelled.

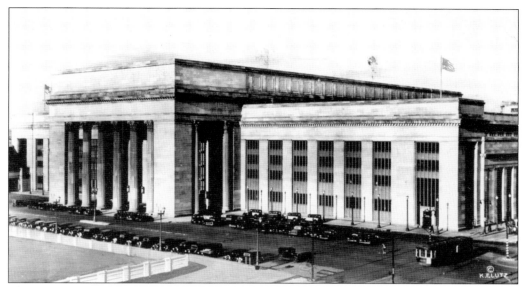

The cars parked in front of the Pennsylvania Station at Thirtieth Street and Market Street appear to have been of 1940s vintage. Due to changes in industrial technology brought about by electrification, the structure of the station, which opened in 1933, permitted trains to pass beneath its ground level without exposing passengers to dangerous soot and carbon monoxide.

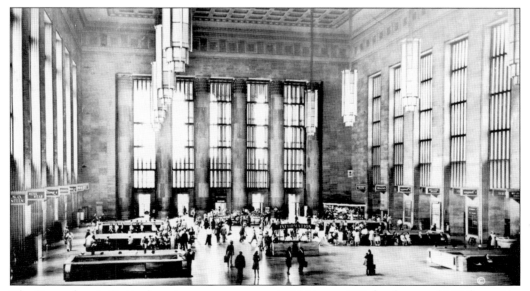

The Pennsylvania Station's main concourse, seen in 1944, was 290 feet long and 135 feet wide, with a height of 95 feet. The walls were faced with Italian travertine marble, and six massive fluted Corinthian columns were installed at its east and west entrances. The Thirtieth Street station was, at one time, an important regional gateway to the northeast corridor.

The Reading terminal, now the home of the Philadelphia Convention Center, is seen in this 1943 photograph. The first train entered the terminal in 1893, and both the Reading Railroad and the terminal closed in 1976. In the 1940s, Market Street, east of Twelfth Street, was considered as the business center of Philadelphia.

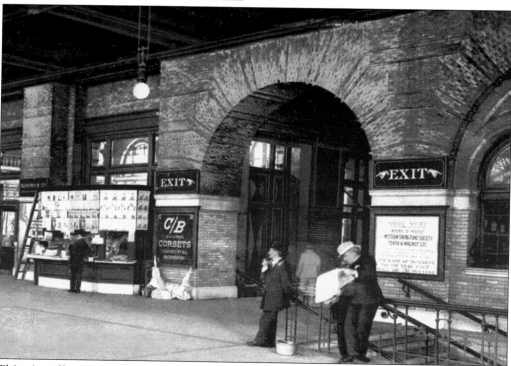

This view illustrates the Reading terminal lobby's appearance in 1909.

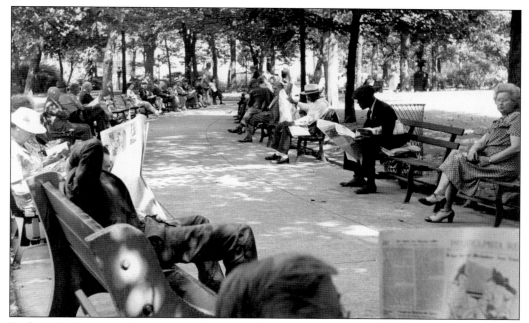

Back in 1946, on any given sunny afternoon, large groups of retirees would sit on the wooden benches in Rittenhouse Square, silently reading their newspapers. The square is located between Locust and Walnut Streets and Eighteenth and Nineteenth Streets. Oblivious to everything else, they forgot to feed the pigeons in the park.

This jovial card was intended for those too busy to write personal messages. A Gray Line bus, parked in front of the Philadelphia Museum of Art, was probably of late-1930s vintage. The Gray Line's terminal was located at Eleventh Street and Chestnut Street and provided sightseeing motor tours through Philadelphia, Fairmount Park, and Valley Forge. (Courtesy of Dennis Lebofsky.)

CHECK ITEMS DESIRED

HELLO	AND I LIKE	PLEASE SEND ME
FAMILY	SLEEPING	A LINE
MA & DAD	TO SWIM	ALARM CLOCK
SWEETHEART	THE FOOD HERE	A PINT
BUDDY	MY ROOM	PAJAMAS
BOY FRIEND	THE PEOPLE	SOME DOUGH
GIRL FRIEND	THINKIN' OF YOU	A GOOD WORD
GOT HERE	IT MUST BE	DON'T FORGET TO
TODAY	LOVE	PUT CAT OUT
YESTERDAY	THE WEATHER	WIND CLOCK
BY TRAIN	LONESOME	FEED THE BIRD
BY BOAT	THE SUNBURN	STAY SOBER
BY PLANE	THE MOONSHINE	CALL FOR ME
AT MEAL TIME	HOME BREW	SEND LOVE
I AM	I NEED	WILL BE BACK
VERY TIRED	YOU	SOMETIME
HAPPY	LOVIN'	SOON
LISTLESS	A PINT	BY MEAL TIME
IN THE DUMPS	MUCH SLEEP	TILL THEN
BROKE	A LETTER	TOODLE-OO
FULL O' PEP	MORAL SUPPORT	OLD THING

BUSY PERSONS CORRESPONDENCE CARD

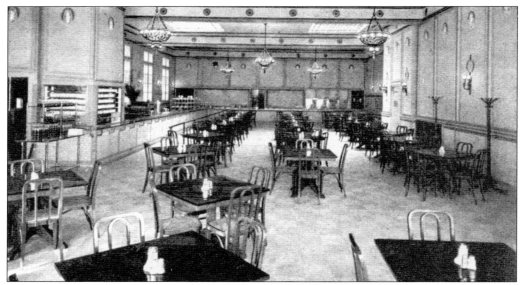

The Spartan appearance of Kugler's Cafeteria, located on the second floor at 30 to 36 South Fifteenth Street, belied the fact that it was advertised as "the most beautiful in America" in this postcard from 1909.

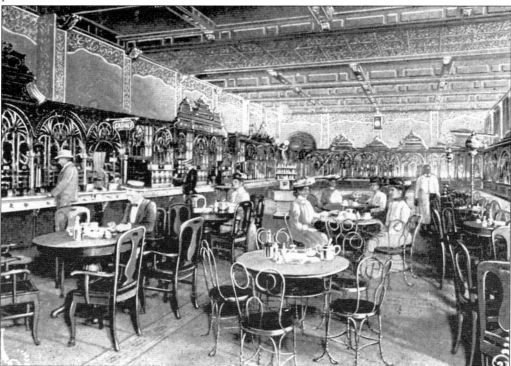

Center City Philadelphia was studded with Horn and Hardart Baking Company's stores. The chain opened for business in 1902, and by 1905, 10 stores were listed in the Philadelphia business directory. The Automat, seen in this 1905 view, was the forerunner of today's vending machines and fast-food restaurants. The last Horn and Hardart Automat closed in 1991.

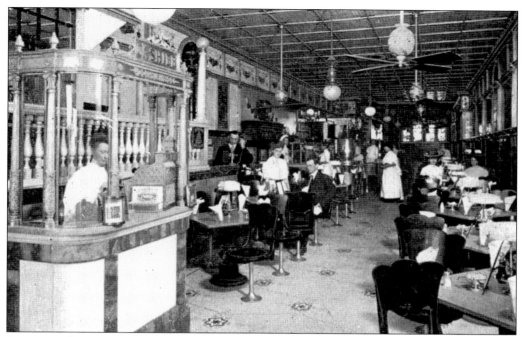

By 1905, the Childs' Unique Dining Hall Company had eight locations in Center City Philadelphia. This 1906 postcard shows its interior design at 706 Chestnut Street. Unlike Horn and Hardart's, it was not a self-service restaurant.

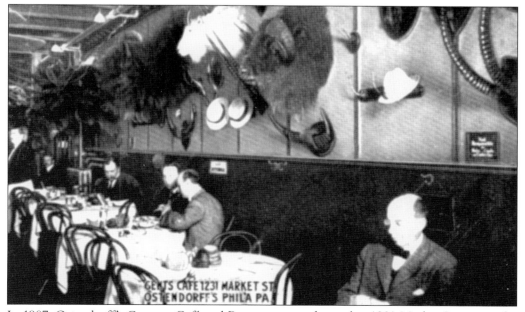

In 1907, Ostendorff's German Café and Restaurant was located at 1231 Market Street, on the same side of the block as the Reading terminal. Typical of a German gentlemen's cafe, the walls were adorned with wildlife trophies. The man at the far right appears to be quite dazed, perhaps having imbibed too many excellent German beers.

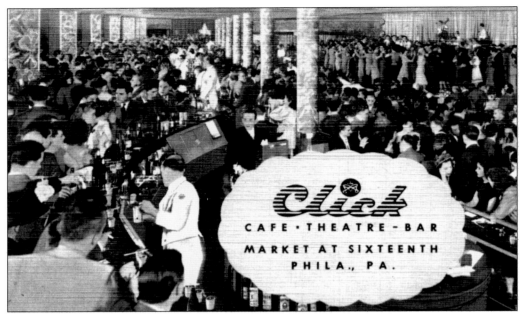

Philadelphia was a major music hot spot in the 1940s and 1950s. Frank Palumbo, a prominent Italian American citizen, was owner of the Click Club in Center City. Advertised as a "black tie saloon," it was frequented by many world-famous pop-singing stars. In 1948, Stan Kenton and his band broadcasted live radio shows from the Click Club.

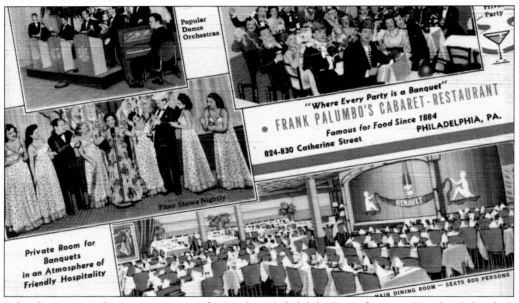

Palumbo was also proprietor of South Philadelphia's infamous Frank Palumbo's Cabaret-Restaurant. In the 1940s and 1950s, Palumbo's entertainment complex, located at 824 to 830 Catherine Street, was host to Frank Sinatra, Tony Bennett, and Bobby Rydell and was often visited by Mayor Frank Rizzo. It operated sporadically after its heyday, and the Palumbo family planned to resurrect the restaurant in 1994, only to see the building destroyed by fire. A Rite Aid now occupies the site.

Eight

EVERYONE LOVES A PARADE

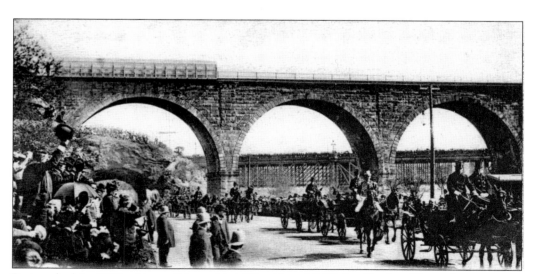

Postmarked in 1905, this card is entitled "President McKinley Passing Through Fairmount Park." McKinley won the Republican nomination at the national convention in Philadelphia in 1900 but was assassinated the following year during his second term of office. The president and his cortege are seen after passing beneath the Girard Avenue Bridge.

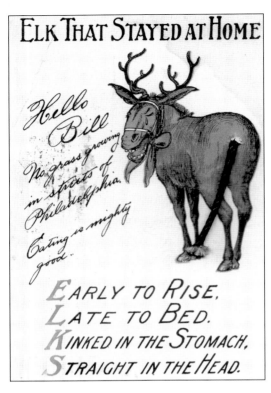

ELK THAT STAYED AT HOME

Hello Bill

No grass growing in streets of Philadelphia.

Eating is mighty good.

EARLY TO **R**ISE,
LATE TO **B**ED.
KINKED IN THE **S**TOMACH,
STRAIGHT IN THE **H**EAD.

The Benevolent and Protective Order of Elks was founded in 1868. The elk, a noble, intelligent, and peaceable animal that would defend itself against a perceived threat, was chosen as the organization's symbol. As its name implied, the order's stated mission was "to do good." That being said, the Elks national convention was held in Philadelphia in July 1907 to reaffirm its mission—and to have a great time.

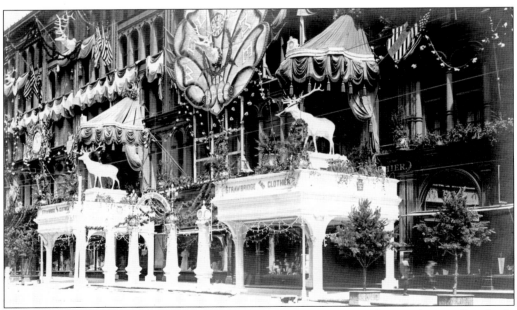

The Elks' greeting "Hello, Bill!" referred to its members' arrival in Billy Penn's city of brotherly love. Philadelphia was bedecked with everything "Elk." Towering columns displaying statues of elks line Broad Street. The entire Market Street facade of Strawbridge and Clothier's store is festooned with Elk regalia.

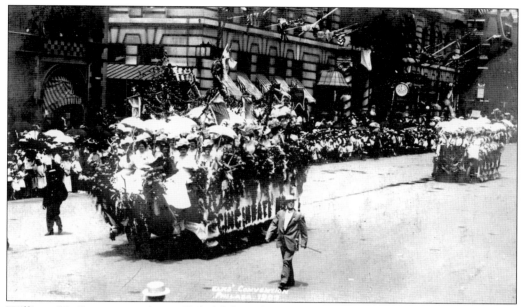

William H. Rau, an eminent Philadelphia photographer, was on the scene to record the week's activities and produced a massive series of real-photo postcards. The wives of the Elks' Cincinnati, Ohio, delegation piled joyously upon their float. Women were not allowed to join the order until 1995.

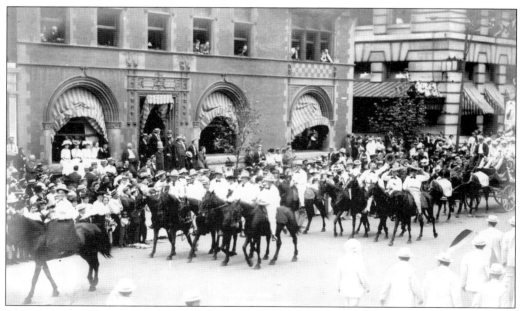

The cowboys and cowgirls of the Montana delegation, sitting atop their trusty steeds, cheerfully wend their way down Broad Street. The Art Club of Philadelphia building can be seen in the background.

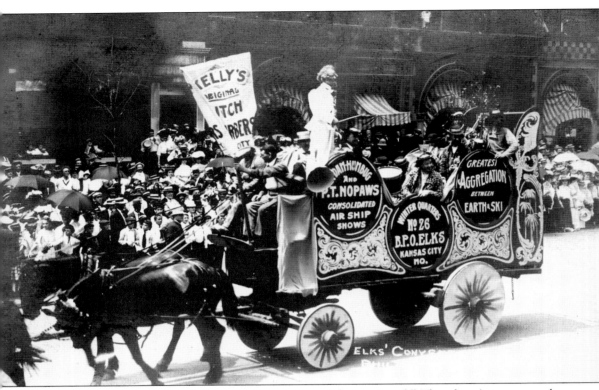

The Kansas City delegation came to the big city to "clown around." The advertisements on the side of float are obviously bogus.

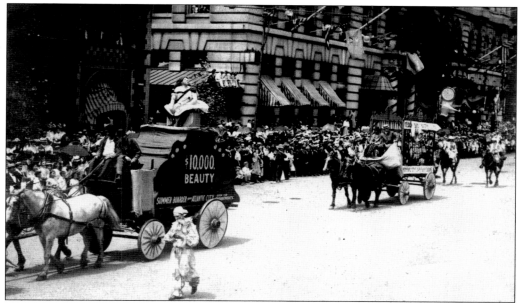

In 1907, Atlantic City, New Jersey, was a fashionable resort town with large upscale hotels and many lesser-class rooming houses. The "$10,000 Beauty" was an indelicate spoof aimed at some of the "ladies" inhabiting these so-called rooming houses. The small print on the side of the float reads, "Summer Boarder from Atlantic City—open for engagements." She certainly was attractive!

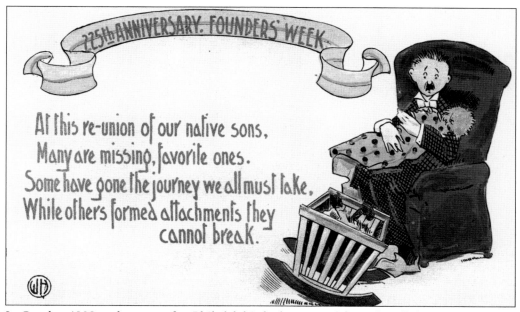

225th ANNIVERSARY. FOUNDERS' WEEK.

At this re-union of our native sons,
Many are missing, favorite ones.
Some have gone the journey we all must take,
While others formed attachments they
cannot break.

In October 1908, only a year after Philadelphia had recovered from the Elks' visit, the city was again host to another extravaganza, the 225th anniversary of the founding of Philadelphia.

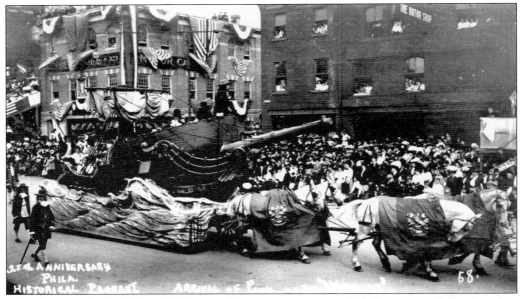

The photographer William H. Rau, again ever present, recorded the events of October 4 to 10, 1908, including its inspiring medley of parades. The gala began with a historical pageant, re-creating cameo events from the life of William Penn. The float in this photograph represented the arrival of William Penn to America aboard his ship the *Welcome*.

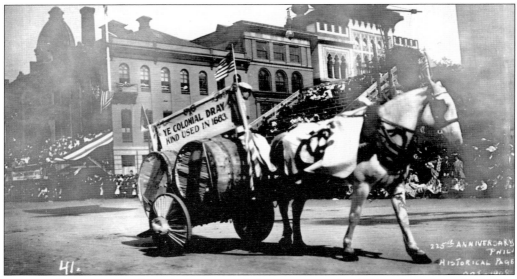

A horse-drawn cart replicated the type of dray common in 1683, when Penn landed in Philadelphia. The photograph was taken at Broad Street and Spring Garden Street. In the background the Spring Garden Street Institute is recognizable on the left. To the right is the Moorish facade of the Lu Lu Temple. Both buildings have been demolished.

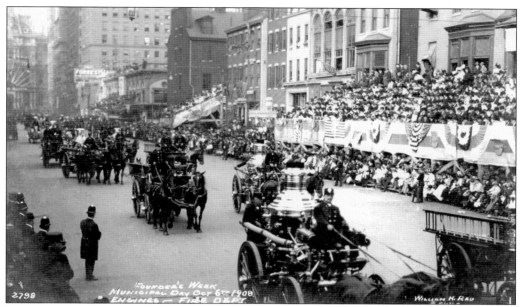

October 6 was both Military Day and Municipal Day. The horse-drawn engines of the Philadelphia Fire Department are proudly on display.

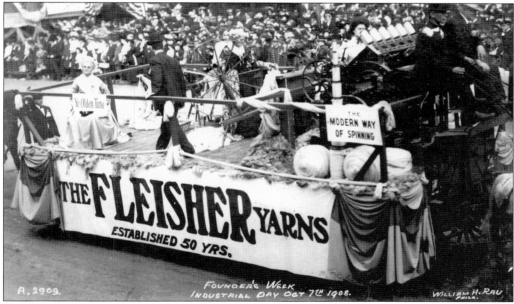

The Fleishers of Philadelphia were wealthy wool and yarn merchants. Samuel Fleisher, son of the owner, was greatly dedicated to his factory workers and their welfare. Upon the death of another son, Edwin, an avid musician, the Fleishers donated his immense collection of music to the Free Library of Philadelphia. William Rau immortalized this float on Industrial Day, October 7.

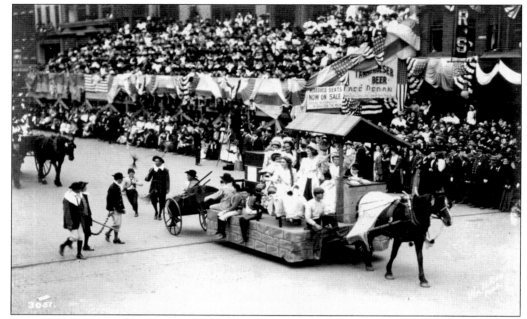

On Historical Day, October 9, the pageantry continued with scene 20 from the life of William Penn. A lovely bunch of wenches riding atop this float were allegedly selling their wares at a street fair.

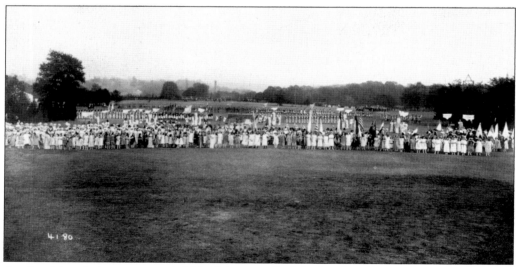

Another historical pageant was held in Fairmount Park in October 1912, and again William H. Rau was the photographer. The huge crowd in the foreground faces the camera, instead of gazing in the opposite direction where the real action, a mock Revolutionary War battle, was in progress.

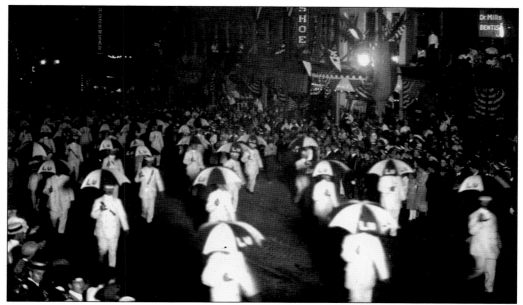

The Ancient Arabic Order of the Nobles of the Mystic Shrine, known as the Shriners, was established in 1870. The organization is fraternal in nature and not connected with any religious group. Brandishing their Lu Lu umbrellas, a group of Shriners strut down South Broad Street during a nighttime parade. The date is unknown but was probably within the first decade of the 20th century.

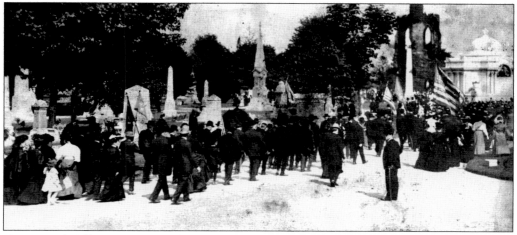

West Laurel Hill Cemetery in Bala Cynwyd, a suburb of Philadelphia, was witness to this parade of patriots. Sponsored by the Grand Army Calvary Post No. 35 on Decoration (Memorial) Day in 1907, the postcard's message reads, "Memorial Day is the day this nation honors its soldier dead. Leave the parks or ball–game and meet me at West Laurel Hill Cemetery in the afternoon."

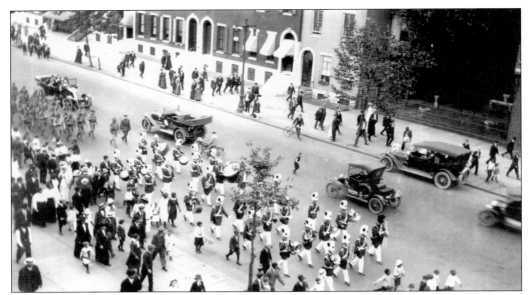

In 1913, a band marching on South Broad Street, attired in full dress uniform, preceded a rather poorly disciplined troop of rifle-bearing soldiers.

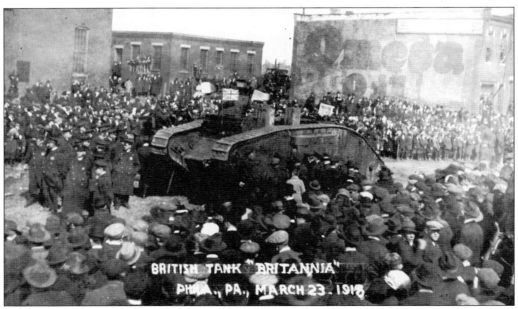

On March 21, 1918, the *New York Times* reported that the British tank *Britannia* had visited Brooklyn on a mission to recruit men to join in the British war effort, and one dozen men had volunteered. Two days later, the tank arrived in Philadelphia, having been met by a gigantic crowd of excited onlookers.

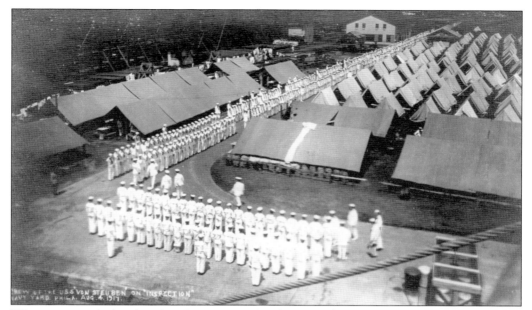

When war was declared against Germany on April 6, 1917, the SS *Kronprinz Wilhelm*, a German raider, happened to be anchored at the port of Philadelphia and was seized in the name of the United States. It was renamed the USS *Von Steuben* and refitted as an auxiliary cruiser. In this photograph, dated August 4, 1917, its crew stands at attention on the parade grounds of the Philadelphia Navy Yard.

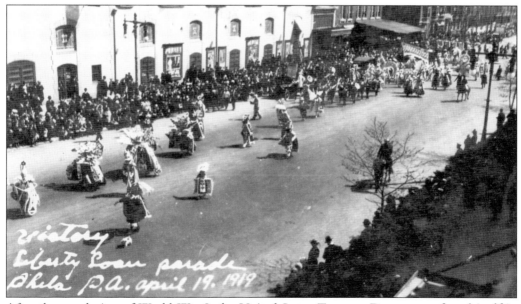

After the conclusion of World War I, the United States Treasury Department found itself in dire need of funds. The sale of Liberty and Victory Loan bonds was advertised, exhorting every man, woman, and child to "do your bit" and to purchase bonds to help uphold America's honor and credit. Campaign awareness was increased with the use of marching bands, balloon ascensions, and parades.

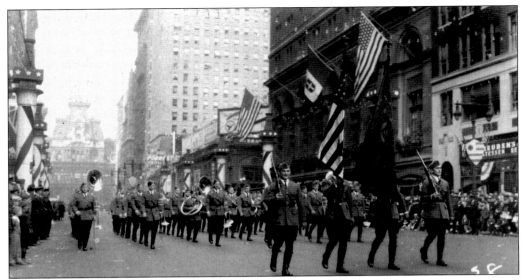

The National American Legion Convention was held in Philadelphia in 1926. Its drum and bugle corps competition was made memorable only by virtue of the poor judging. A winner could not be selected since the judges had scored each corps either as "good" or "very good." This parade was staged on South Broad Street on October 12, 1926.

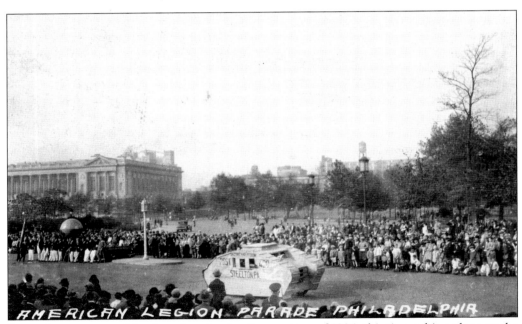

In another segment of the American Legion Convention of 1926, this time taking place on the Benjamin Franklin Parkway, a mock-up of a World War I tank was driven by members of the legion post from Steelton, Pennsylvania.

In this scene from the 1950s, snapped on north Broad Street during the Gimbel's Thanksgiving Day parade, a Philadelphia policeman was purposefully ignoring a man dressed in a monkey suit. The Philadelphia event was initiated in 1920 and is the oldest such parade in the country. (Courtesy of Dennis Lebofsky.)

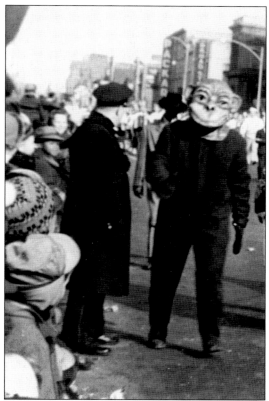

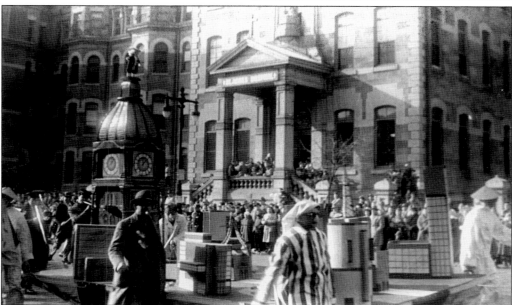

The Philadelphia Mummers Parade has been held every New Year's Day since 1901. In 1952, a comic division club sauntered up South Broad Street, posing in front of St. Agnes Hospital. The ornate clock was part of the club's presentation. (Courtesy of Dennis Lebofsky.)

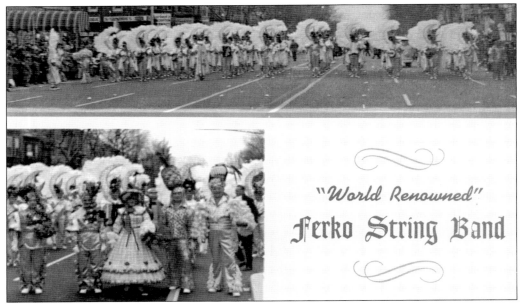

"World Renowned"

Ferko String Band

The Joseph A. Ferko String Band has been a Philadelphia institution since 1922. The club's 1965 theme was a musical "Horn of Plenty," and the musicians were dressed up as fruits. The entire string band was televised in a 1963 broadcast of the game show *I've Got a Secret*.

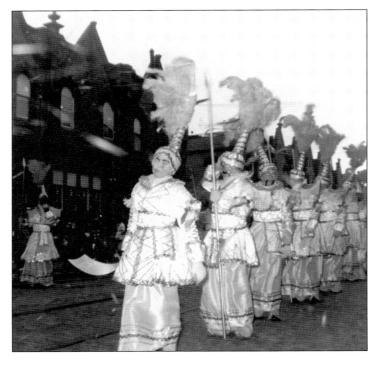

Since many of the participating New Year's clubs had headquarters located on South Second Street, they were colloquially dubbed "Two Streeters," and informal tradition had the parade ending in South Philadelphia. This 1957 view of one of the "fancy" clubs, taken by the author, was photographed at the corner of Third Street and Ritner Street.

Nine

A City of Museums and Culture

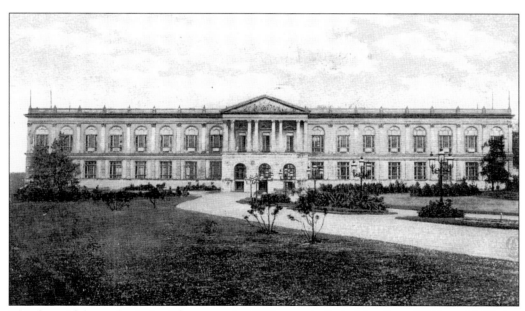

This beautiful neoclassical edifice, seen in 1907, was dedicated by Pres. William McKinley in 1897 and opened in that year as the Commercial Museum. After the massive National Export Exposition of 1899 ended, the building was the site of the 1900 Republican national convention. It was then again returned to its original purpose as a museum. Unfortunately, it was demolished in 2005.

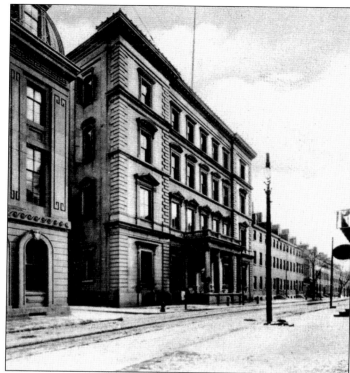

In 1901, this postcard, entitled "Philadelphia Commercial Museum," looked far different from the building seen on the preceding page. A 1902 guidebook explained that this was the old, original Commercial Museum, located on Fourth Street, below Walnut Street, and was to become the future home of the National Export Exposition of 1899 after that event closed.

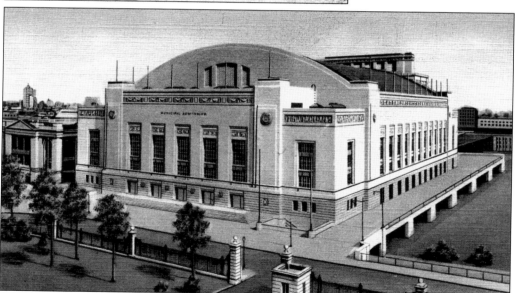

After the Municipal (later, Convention) Hall was built in 1931 at a cost of $5.3 million (around $71.5 million in 2007 dollars), the Commercial Museum was designated as part of its complex. The hall was the site of both the 1948 Republican and Democratic national conventions. Philadelphia had been chosen for the first video broadcast of national conventions, and both political parties had actually agreed to accommodate the television networks by utilizing the same building.

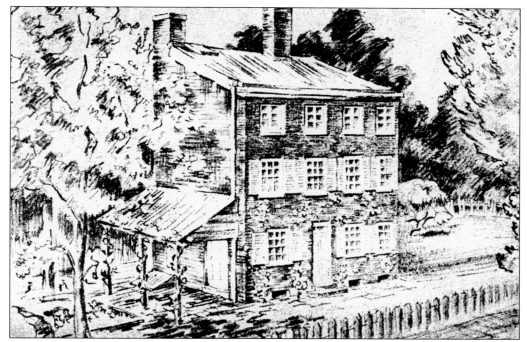

Edgar Allan Poe resided at 530 North Seventh Street between the years 1842 and 1844. It was while dwelling there that he created his famous poem *The Raven*. Poe died in 1849 at the age of 40. This is an artist's rendition of Poe's home, issued in postcard form in 1934.

Taken from the same set of postcards, this is a sketch of the parlor in Poe's "Rose-Covered Cottage."

Till förmån för
Fredrika Bremer-rummet
i Philadelphia 1938

The building in the inset is the American Swedish Historical Museum, the oldest Swedish institution of its kind, founded in 1926, and still in existence today. Located in South Philadelphia, it is close to Franklin Delano Roosevelt Park. The portrait is that of Fredrika Bremer (1801–1865), a famous Swedish feminist, activist, and writer.

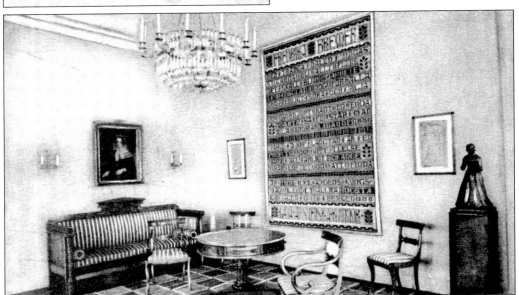

The museum houses relics and artifacts of great significance to the Swedes in America. In 1938, this room was dedicated in honor of Fredrika Bremer, whose portrait is seen in the preceding postcard. Another of the museum's rooms was decorated in honor of Jenny Lind (1820–1887), the opera singer known as the "Swedish Nightingale."

An interior view shows the gracious and magnificent entrance hall of the American Swedish Historical Museum.

The Witherspoon Building, located at 130 South Juniper Street, also called the Presbyterian Board of Publication Building, was erected between 1895 and 1897, and is now on the National Register of Historic Places. It was dubbed Philadelphia's first skyscraper, since its skeleton was constructed of steel I-beams. The postcard is from 1906.

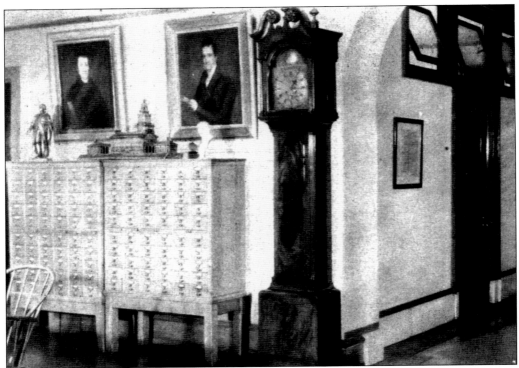

John Witherspoon was the only practicing minister to sign the Declaration of Independence. In 1906, the Presbyterian Historical Society was located in the Witherspoon Building. On display in its museum was Reverend Witherspoon's clock. Witherspoon was, at one time, president of the College of New Jersey, now Princeton University.

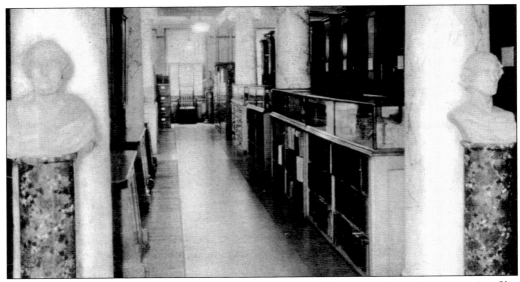

The Presbyterian Historical Society had a vast array of book stacks and manuscript files in its research library. The society now maintains its own building at 425 Lombard Street in Philadelphia.

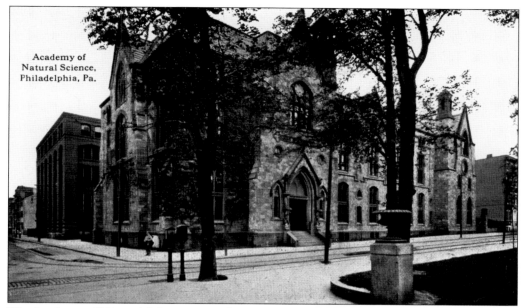

The Academy of Natural Sciences moved to its present building at Nineteenth Street and Race Street in 1876. This postcard view was taken prior to 1910, before its facade had been radically altered and reappointed with red brick and marble trim.

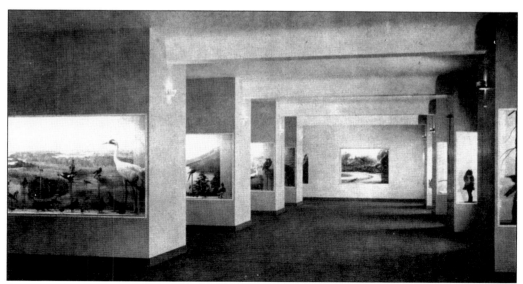

A 1940s photograph of the Academy of Natural Sciences' Audubon Bird Hall illustrates its rather stark appearance. The interior of the museum has been extensively renovated and made much more user friendly for the enjoyment and edification of adults and children of all ages.

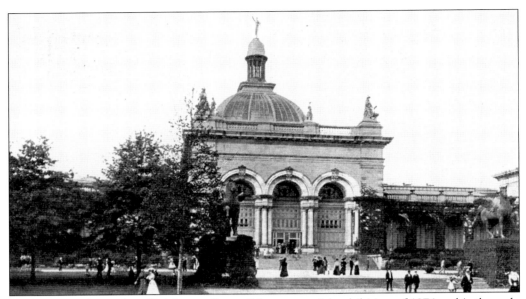

Memorial Hall was the official art gallery of the centennial exhibition of 1876 and is the only remaining permanent building of that event. After the conclusion of the centennial, it was renamed the Pennsylvania Museum and was again utilized as an art gallery. Its interior has recently been lovingly restored and in 2008 reopened as the Please Touch Museum.

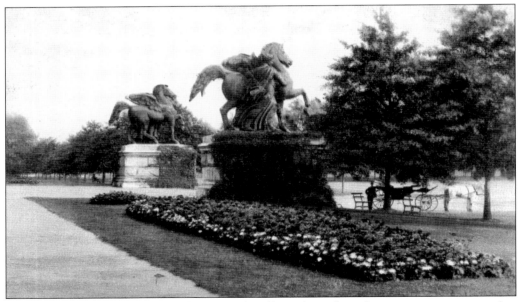

Guarding the exterior entrance of Memorial Hall stand two huge bronze statues, representing Pegasus led by the Muses. The mammoth pair was created by Vincenz Pilz for the Vienna Opera House. The Viennese criticized the disproportionate size between the statues and the opera house, and the statues were discarded. They were later rescued by Philadelphian Robert H. Gratz. This postcard is from 1907.

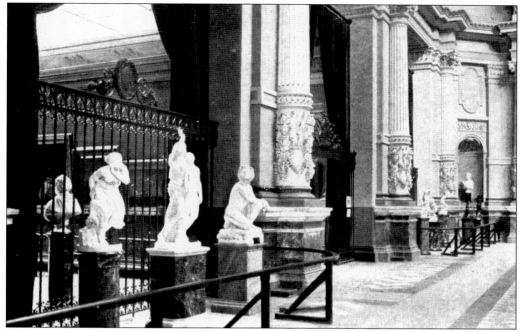

W. P. and Anna H. Wilstach were great collectors of great art, and after the probate of Anna's will in 1892, over 500 oil paintings and sculptures, as well as the funds to maintain them, were bequested to the Fairmount Park Commission. The Wilstach Gallery was housed in the western wing of Memorial Hall until it was moved to the Philadelphia Museum of Art. This postcard is from 1906.

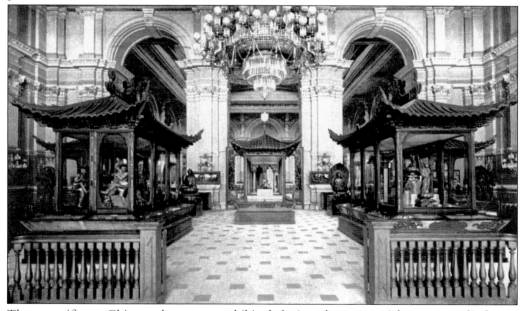

The magnificent Chinese showcases, exhibited during the centennial, were on display in Memorial Hall when this postcard was mailed in 1915. The splendor of the hall's interior design can also be appreciated in this view.

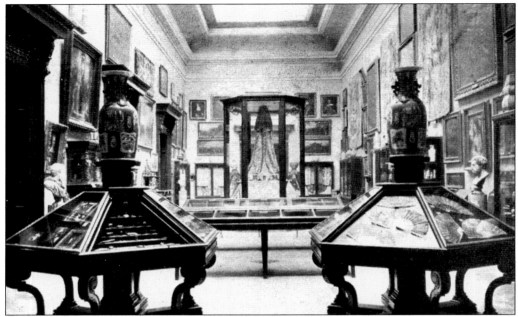

Clara Jessup Bloomfield-Moore, a patron of the Pennsylvania Museum, travelled throughout Europe, amassing a collection of valuable *objets d'art*. Beginning in 1882, she donated her huge collection of paintings, enamels, jewelry, carved ivories, and many other items then considered as industrial arts. This postcard from 1905 reveals only a portion of that collection.

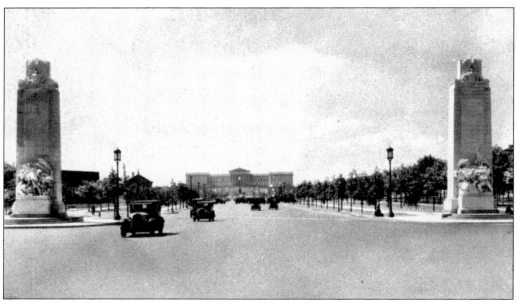

The Benjamin Franklin Parkway was the brainchild of French urban planner Jacques Greber. In 1917, he created an avenue that was to be the equivalent of Paris's Champs d'Elysee. The army and navy pylons in the foreground were erected in 1927 in commemoration of those who died in the Civil War and stand at Twentieth Street and the parkway. The Philadelphia Museum of Art is seen in the far background.

As part of its public relations incentive, the city of Philadelphia developed the concept of "Super Sunday." This October 1973 view was photographed from the steps of the Philadelphia Museum of Art, looking toward city hall, which can be seen looming in the center background. The super event was celebrated by more than 400,000 attendees.

The statue of Benjamin Franklin, first postmaster of the United States, sculpted by John J. Boyle, was unveiled in 1899. It was placed outside the post office at Ninth Street and Chestnut Street in 1905. When the post office was demolished, the likeness of Franklin was moved to College Hall on the grounds of the University of Pennsylvania.

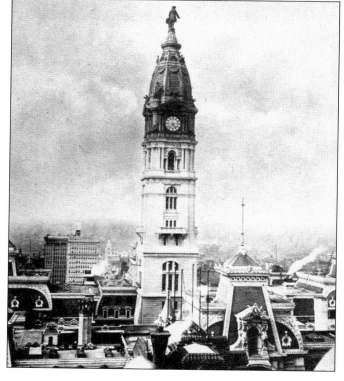

Rising 548 feet into the clouds is Alexander Calder's 27-ton, 37-foot-tall masterpiece, the statue of William Penn, set atop city hall. Penn faces in a northeasterly direction toward Penn Treaty Park, where he and the Leni Lenape Indians bonded in friendship. When this postcard was taken in 1905, city hall was the world's tallest habitable building.

Ten

SIGNS OF THE TIMES

Brandishing a mean–looking baton, this dour nurse was indeed the ultimate poster girl for the Philadelphia Pure Food Show of 1909. After the Pure Food and Drug Act was declared law in 1906, regulations mandated that all commercial products and drugs be properly prepared and labeled. At this food show, women's organizations focused primarily on housekeepers, teaching the art of cooking, and on general household economy.

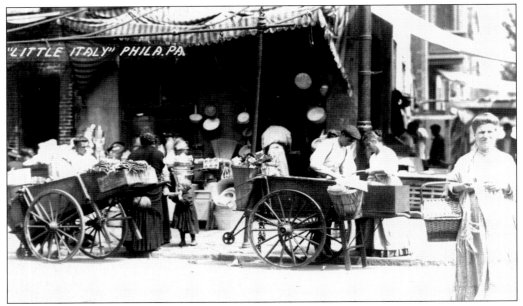

The Bella Vista area of South Philadelphia, the neighborhood between South Street and Wharton Street, and a few blocks on either side of Ninth Street, was commonly known as "Little Italy." After 1884, a significant number of Italian immigrants gravitated there, many becoming vendors or laborers. This early-1900s photocard captures a cameo glimpse of that industrious community. (Courtesy of Dennis Lebofsky.)

This *c.* 1976 view of Little Italy and the Italian Market may in fact have been taken at the same spot seen in the previous photograph. There has been an influx of non–Italians into the area, and many of the stores are now owned by Asian and Mexican businessmen.

Fudgy's Shoppe was located in the heart of the Italian Market, at 1026 South Ninth Street. Fudgy's boasted that it handled the same exclusive lines of women's and teenage apparel that might be found in elite Center City and suburban stores. The fashions displayed in the window are so 1960s!

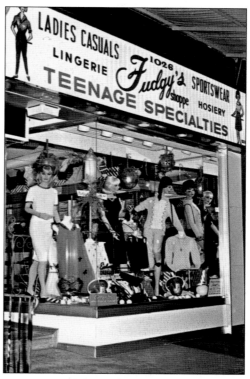

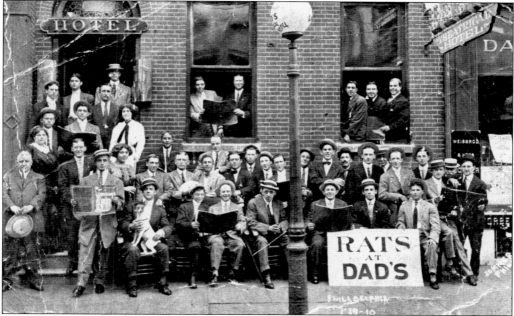

In 1910, a group of thespians congregated outside Dad's Theatrical Hotel, protesting that the establishment was infested with rats. Ironically, the photographer caught these gentlemen smiling and looking strangely upbeat in spite of the gravity of the situation. There was no recorded listing of "Dad's" in the 1910 Philadelphia directory. (Courtesy of Dennis Lebofsky.)

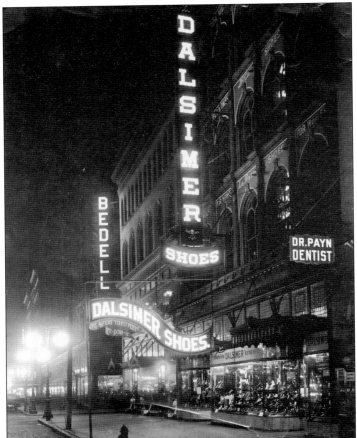

Dalsimer's Shoe Store was situated at 1204 Market Street. It was owned and operated by Sylvan Dalsimer and his sons Milton and Herbert. Hopefully, Dr. Hiram Payn, whose dental office was located at nearby 1210 Market Street, was gentler than his name implied. This photograph is from 1914.

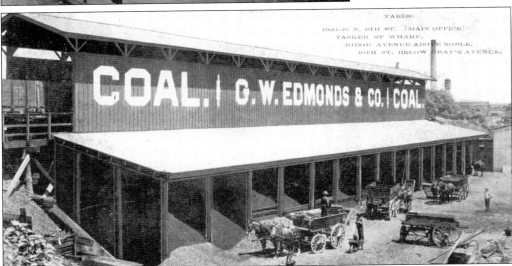

The 1907 Philadelphia city directory listed five pages of coal dealers. In that year, the G. W. Edmonds Company had quite a thriving business, with four coal yards located in various sections of the city. This postcard shows the horse-drawn wagons that delivered the "black diamonds."

In 1915, the *New York Times* reported that the Federal Trade Commission was investigating allegations that gasoline prices at the pump had soared to a staggering 8.81¢ per gallon ($1.82 in 2007 dollars). This cute little Atlantic Service Station, located at Broad Street and Carpenter Street, advertised that its parent company had set new standards for the quality of its gasoline and motor oils.

In the 1920s and 1930s, due in part to the lack of home air-conditioning, it was fashionable for homeowners to switch from heavy woolen winter rugs to those of lighter summer weight. The Atlas Storage Warehouse Company advertised special vaults for the summer storage of furs, rugs, and drapes since keeping such valuables at home during hot weather was fraught with the danger of insect damage.

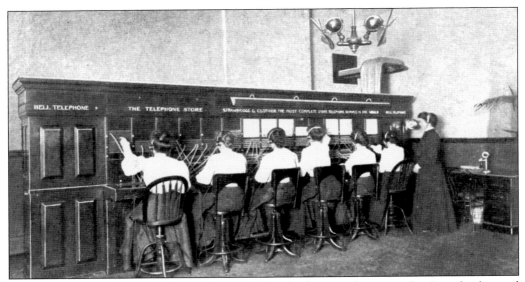

This is a 1907 view of the busy high-tech Bell Telephone exchange at the Strawbridge and Clothier department store. The switchboard was, in fact, "digital." In other words, the telephone operators pushed and pulled the plugs with their fingers.

Antique postcard collecting is a form of voyeurism. The message written on the back of a card may be as revealing as the image on the front. The reverse side of this 1907 postcard provides an insight into the technology of the times.

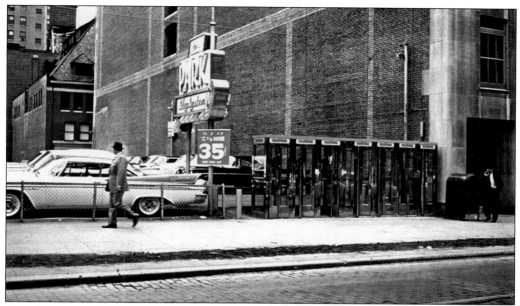

The Sherron Metallic Corporation, makers of telephone booths, which were "of spanking smart stainless steel, enduring and bright," commissioned this giant advertising postcard in 1959. Seen here is a bank of their telephone booth products at Sixteenth Street and Chestnut Street. The Sley System parking lot charged an exorbitant 35¢ per half hour ($2.45 in 2007 dollars).

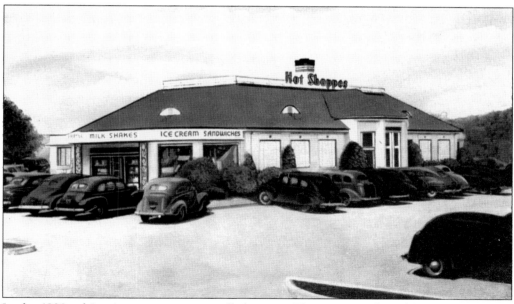

In the 1930s, drive-in restaurants were all the rage. The concept of quickly prepared meals, served by a carhop in the comfort of one's automobile, rapidly became popular in Philadelphia, its suburbs, and elsewhere. The red roofs of the Hot Shoppes were an instantly recognizable icon. Several corporations have recently "gone retro" and reinstituted this method of fast-food delivery.

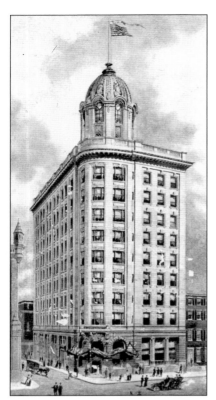

The proposed *Evening Bulletin* building, seen in this 1907 view one year before it actually opened, was located at City Hall Square, the center of Center City life. In 1947, after purchasing the *Philadelphia Record* newspaper, the *Sunday Bulletin* was born.

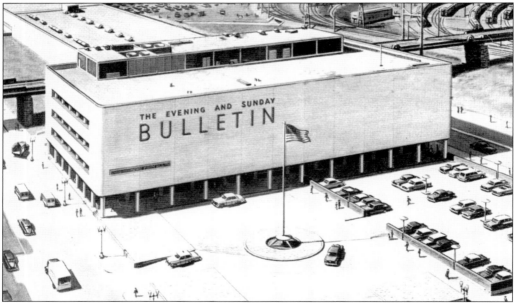

In 1955, the *Evening and Sunday Bulletin* was relocated to a six-acre lot at Thirtieth Street and Market Street, the publication's sixth home since 1847. Designed by Louis McAllister Jr., it was touted as the world's most modern newspaper plant. The *Bulletin* closed in 1982, finally succumbing to pressures from the loss of advertising revenues.

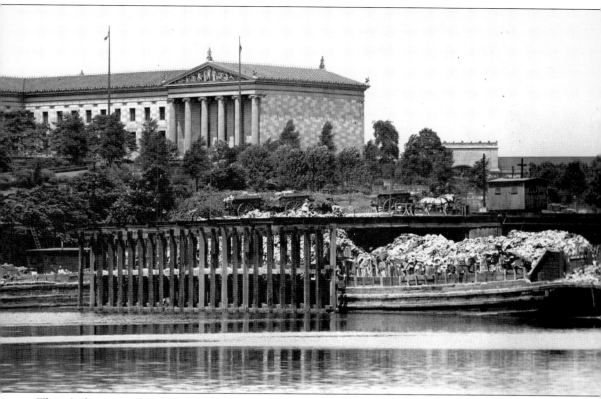

The city's accumulated fly- and vermin-infested trash and garbage was loaded onto barges before being hauled down the Schuylkill River, but not before having been seen by thousands of commuters riding on the Pennsylvania Railroad lines. This photograph, taken from a vantage point along the West River Drive in 1946, is in stark contrast to the beauty of the Philadelphia Museum of Art in the background.

ACROSS AMERICA, PEOPLE ARE DISCOVERING SOMETHING WONDERFUL. *THEIR HERITAGE.*

Arcadia Publishing is the leading local history publisher in the United States. With more than 3,000 titles in print and hundreds of new titles released every year, Arcadia has extensive specialized experience chronicling the history of communities and celebrating America's hidden stories, bringing to life the people, places, and events from the past. To discover the history of other communities across the nation, please visit:

www.arcadiapublishing.com

Customized search tools allow you to find regional history books about the town where you grew up, the cities where your friends and family live, the town where your parents met, or even that retirement spot you've been dreaming about.